Keys to Crea

Creative Me

Elliott

Helen Elliott

Photography Caitlin Tyler

A practical guide to the joy of paint

Creative Me: Keys to Creativity
Published in Great Britain in 2016 by
Graffeg Limited.

Author Helen Elliott copyright © 2016.
Photography by Caitlin Tyler copyright
© 2016. Designed and produced by
Graffeg Limited copyright © 2016.

Graffeg Limited, 24 Stradey Park
Business Centre, Mwrwg Road,
Llangennech, Llanelli,
Carmarthenshire SA14 8YP Wales UK
Tel 01554 824000 www.graffeg.com

Helen Elliott is hereby identified as the
author of this work in accordance with
section 77 of the Copyrights, Designs
and Patents Act 1988.

A CIP Catalogue record for this
book is available from the
British Library.

ISBN 9781910862582

2 3 4 5 6 7 8 9

Just be
in this moment
absorbed and inspired
by who you are
and what you love,
where you are
and what you do.

Contents

Foreword

by Patti Brady

I had the pleasure of meeting Helen in one of my favorite cities, New Orleans, LA, during a week-long training I was giving to a select group of artists. Over the week, I had lovely talks with her and I instinctively knew that she was a unique soul and easily imagined that she would be an amazingly gentle and supportive teacher.

Then she sent me her book and I knew that I was absolutely 'spot on' with my intuition. Helen's experience and professional qualifications as a psychologist are obvious throughout. Her wisdom here does not require paint, and could be applied to any creative endeavor.

But I am glad it is all about paint. I am a painter and I have worked for GOLDEN Artist Colors as the Director of Educational Programs for over twenty-three years. In my tenure I have met hundreds of artists, trained over two hundred in my programs and written a book on the use of acrylics, titled *Rethinking Acrylics*.

I am delighted to recommend Helen's book to beginners and advanced painters alike. For beginners you will find all the encouragement you need to keep on painting right through all your insecurities. Helen will have you understanding the hills and the valleys before you reach them. Advanced painters will be reminded of all the soul and courage that is required to continue to explore your painter's journey.

This book is full of great tips for all stages of your painting experience. When discouraged or feeling without inspiration, flip through the book for words of encouragement from Dr. Seuss, Edward Hopper and Picasso!

Now, don't think too much, get this book, grab some delicious high quality paint and begin your creative journey.

Patti Brady
Director of Educational Programmes
GOLDEN Artist Colours
New Berlin, New York.

Introduction

'Generosity isn't just about giving in a material way. If you can teach or inspire another person, that is an excellent practice of generosity; and inspiration is one of the greatest gifts.' HH Gyalwang Drukpa

Thank you for joining me, and others, in taking this creative journey. This method of accessing and developing artistic creativity is suitable for absolutely anyone who wants to explore their creativity and have some fun with paint. Genuinely and absolutely no experience is necessary – you may have never painted or you may be an experienced artist – it doesn't matter.

Everyone can enjoy this exciting approach to creating beautiful unique artwork.

Why this book?

The knowledge I'm excited to share with you in this book is distilled from my lifetime of creating and a lot of frustration. No – please, no sad faces here. This is not a sad story. The message is this: creativity is a life force, it's been around since the dawn of humanity and it will be with us until the end. It's a natural process that is going to find an outlet somehow, so you might as well have a good time whilst it's doing so. To help your creativity to bloom in a way that will fill you

with joy and excitement here are some ideas I'd like to share with you. I want to share what has worked for me, with the desire that it will work for you too.

I believe that anyone who wants to paint can paint, and can do so in an enjoyable and relaxed way without the frustrations often associated with creativity.

To start with, I'd like you to think of a classroom of five-year-olds. Think of their excitement when the paint and crayons come out. I often work with very young children in classrooms and the first question I ask them is "who here likes to paint, who is creative?" I can tell you, just about every single hand goes up, and not just up, but up with an absorbent energy, no hesitation, just a massive, affirming "Yes Me!!!"

That's the kind of creative joy I'm talking about.

I've learned, from my own experience and from talking to many others, that we are all born with a desire to create. It may not be visual art; perhaps it's dance, song, music, writing, theatre, cooking, yoga, any kind of activity that gets you into a place where time stands still, and your heart fills with joy. This book focuses on the visual aspect of creativity, in particular the application of paint, acrylic paint to be exact. This is because this type of paint is, to me, the most wonderful, delicious, vibrant type of paint and, amazingly, it is also the easiest to work with because it is very forgiving. More opportunity for more joy.

We are all creative

We are all creative, but often we are easily dissuaded from the creative path because that brief burst of joy has vanished. We become disillusioned, convinced that we'll never find it or hold onto it; that all that lies on the path to creativity is frustration and heartache.

But this is not true.

The reason this book came into being was because I needed to communicate an answer to a question I have been asked many times. Sometimes it comes to me as a statement, and it's a sad statement. It goes like this. "I would love to paint but I can't." It has many variations "I used to love to paint" or "I'm just not creative". You get the idea. You may even be saying it to yourself right now.

I call it a question because what people were asking was "how do you do it?"

I call it sad because there is such joy to be accessed through creativity which people stubbornly deny themselves when they label themselves as not artistic or not creative.

Instinctively I knew, positively and without doubt, that I wanted to say to these people *"Yes, you can paint. Yes, you are creative. Let's look at how we can get through all that stands in the way of being confidently creative. Let's do this!"*

So I started to research, to look, to read, to absorb, and to understand just what happened to that class of five-year-olds who all held their hands up when asked if they like to paint making them into adults who genuinely believed they couldn't.

And you know what happened when I thought about this question and talked about it? I realised that all the experiences I've had up to now in my life, up to this very point in time, all the creative frustrations, disappointments, challenges, satisfactions and successes, have led me to being able to write this book and hopefully, to inspire and encourage your precious creativity to bloom.

Using the psychological insights gained from

Creative me, age about 8

many years working with change behaviour in adults, I realised that what gets in the way of our creativity is not a lack of skill with paint. No, it's the stories we make up, and believe, about how we aren't creative . These stories protect us from our fears – fear of failure, of ridicule, of joy, of selfishness, of strangeness, of scariness, of rejection, of being 'an artist' and a whole range of other possibilities that we think we know are there when we say yes to being creative in our lives. The laughable thing is – and I do mean laughable, because there's no point in crying over it – is that a lot of these fears are not based on any form of facts at all. Instead, they are just unexamined stories we have made up for ourselves.

As the creative genius Liz Gilbert said in her recent book Big Magic – "there's a lot of fears that can get in the way of creativity. And, I believe, the more creative a person you are the better you are at making these fears up, and making them huge and scary too!"

That's why this book is so much more than a 'how to paint' guide, we'll also have a good look at these stories we tell ourselves and see what can be done about them in order to let our creativity blossom.

This book owes a lot to my teachers, in various disciplines and places, and to the brave and trusting artists who have joined me on my Creative Me workshops over the last six years. I'd like to thank them for teaching me and inspiring me to write this book. Here are some of their three word summaries of their own personal Creative Me experiences.

"unsettling, unnerving, releasing"
"rewarding, therapeutic, stretching"
"challenging, frustrating, invigorating"
"absorbing, testing, encouraging"

Ready to join them? I do hope so.

Creative confidence

'If you could say it in words, there would be no reason to paint.'
Edward Hopper

I have come to believe that the technical knowledge of paint and its physical application is in fact only a small, but essential, part of being a happy, successfully creative artist; literally the tip of the iceberg.

The evidence is clear. Anyone can learn the simple process of applying paint to canvas. What I'm interested in, and what the Creative Me workshops explore, is the rest of the iceberg. What is it, apart from the technical know-how, that helps people be successfully and happily, creative. I think it can be summed up in these three words: intention, attention and attitude.

In artistic terms our **intention** is the part that we always see, the tip, the "how to paint" part. We can set our intention to develop our knowledge and skills in the use of paint, and to dedicate time to doing so. We can develop our awareness of what we choose to pay **attention** to, in other words, what inspires us. Add to this our **attitude**, which includes being brave, being committed, staying curious and grateful and voila, before you know it we have a very fertile field in which our creativity can grow.

I believe that creativity, in all its forms, comes from a very deep desire to communicate. In trying to do so – as with trying to communicate in any language – there will be some thrills when you understand what's being said and others understand you; and quite a few lows when you're not understood at all and feel you may as well give in. However, if you prepare yourself with psychological tools for your creative journey with the same care and dedication that you choose your paint and learn how to use your physical tools, then your path will be smoother and easier.

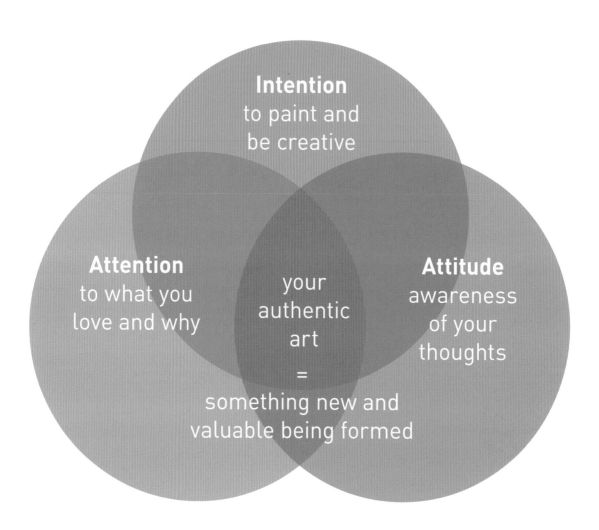

Intention
to paint and
be creative

Attention
to what you
love and why

your
authentic
art
=
something new and
valuable being formed

Attitude
awareness
of your
thoughts

For example, if you use old, cheap paint and thin paper, it will be hard to get good results. Choose professional quality paint, add a good canvas, a warm well-lit place to work and you will immediately increase the chances of success.

Well, the same applies to our attitudes, our mental preparation. It's not hard, and unlike some top quality paint, it costs no money, only a little time and thoughtfulness.

What I know about being creative

Our intentions, attention and attitude are the cornerstones to creativity.

Creativity involves having an idea and turning that idea into a reality. What follows are the 'attitudes' I have learned help you achieve this. Have a read through and see what you think. It may be helpful to write down or 'draw out', yes literally draw them in your

sketch book, what your initial thoughts are as you read. Remember that even as you read these words and become aware of your responses to them, you are developing your creative ability. Once your thoughts have been thought, they will have an impact on how you act and think in the future.

Our thoughts are more powerful than ever we can imagine, because it is with our thoughts we create our world.

Be brave

When we embark on any creative process, our fears, doubts and insecurities will naturally come to the surface. This is good – this is progress. Think of each not as a problem, but as a stepping stone in our creative lives.

We should face our fears. It is true that life shrinks or expands according to our courageousness. Be brave in facing your fears – why not? Seriously, what have you

Our thoughts are more powerful than ever we can imagine, because it is with our thoughts we create our world.

'A flower doesn't go from bud to blossom in one spritely burst.'
Maria Popova

got to lose? This is a fact: at the end of the day it's only paint and canvas. The rest is thoughts and feelings which are our own constructs, and it is totally and solely within our power to choose which of these thoughts we will engage with, and to change those that are not helpful.

Exploration is essential, encouragement is not

As we become braver, we will explore more, and as we explore more we will be experimenting. By allowing ourselves space to experiment, opportunities will naturally develop to explore new ideas and solutions, and so creativity starts to grow.

The people this book is written for, those who have visited my studio or contacted me online and who have said, 'I'd love to paint, but I can't,' those people who label themselves 'not creative' have often been discouraged from being creative by being judged in their

childhood. It's not that they are not creative, more that they're afraid to try. I learned this first hand. As a child of about thirteen years old I was asked to leave the art class and told I couldn't draw. Although from an early age painting had been my passion, my drawing was judged 'not good enough' and I was asked to reconsider my study options and told that the art class was not for me.

We have to have confidence in ourselves, because we are the only ones who can discover what we can do with our creativity. People may tell you that you won't be able to do things, or that you are doing things wrongly, but if you believe in yourself, you can do it. Encouragement from others is not essential; believing in your passion is. The 'Creative Me' method of painting is based on simple techniques that facilitate early success for artists. The more success we can experience at the start of our creative adventures, the more confidence in ourselves we generate. In this way we can change our stories and start to believe in our abilities.

Think of your creative journey as a series of explorations rather than mistakes or failures. This applies not just to the skill of applying paint to paper. We can allow ourselves space to experiment with our thinking too in order to learn. And there's going be a lot of learning. Once we commit time and space to our creativity this learning will happen naturally through a process of evolving experimentation and opportunities.

If we can encourage ourselves to think about 'failure' in a positive light we will not only become more creative, but more resilient too. If we regard our less than successful paintings not as reasons to give up, or evidence that we can't paint, but as intriguing and educative experiments, we can continue with courage and curiosity along the way.

You see, learning to be creative is about learning to love, or at least accept, our frustrations and 'experiments'. It's about welcoming these and learning from them, acknowledging that they are necessary for creativity to grow. They are like the manure we put on our roses in order for them to bloom beautifully. You will create paintings and you will be dissatisfied with them. Guaranteed. There will be elements of joy-filled loveliness within them, but the next moment you'll feel that something is just not right.

The ambiguity we feel when something is so right but the next moment so wrong is in fact an excellent place to be. Yes, it's uncomfortable, yes it's scary and yes it would be great to immediately produce a masterpiece, but the fact you feel the painting is not quite right means you are successfully accessing your very own precious creative intuition. The discomfort you feel is essential to your next breakthrough. We all have access to a deep stream of intuition within us which is easily accessed if we remember to pause, breathe and tune in. By learning to do this we can access our creative intuition easily without getting to the point of frustration.

This discomfort is your intuition talking to you. Listen to this intuitive voice. This is your teacher. You are lucky to have heard it. OK, so you don't yet know exactly what it is that needs to change in the painting. That's what

the rest of your life and some suggestions in this book are about. Choose to stay with this discomfort awhile. It's frustrating but it won't bite. Stop, Look, and Listen. Make tea. Take time to sit and reflect on not only the painting process, the colours and lines, but also your thinking process. How are you handling any discomfort? Be nice to yourself. You're learning and you're doing well.

A word of caution for we have another ambiguity. Yes we need to pause and assess but at the same time, we need to avoid over-analysing. It's our intuition we're connecting with, not our logical, analytical mind, nor some half remembered magazine article on 'how to paint'. Overthinking our painting allows worry, doubt and fear to creep in which blunts our creativity. When you find yourself with these unhelpful thoughts, take a breath, be brave and dive into the painting, make a mark, go with the flow using your intuition to guide you. Keep in mind that it's only paint and it's only canvas, and it doesn't have to be finished by tea-time.

Creative intuition is something all of us artists possess, it's what tells us something is 'not quite right' and it is the same intuition that urges us on, to create again and again, until we get a glimpse of a pleasing result. We should listen to this 'again and again' urge. Most of the time we don't give it a chance, enthralled as we are by the expectation of immediate success. Whereas, in reality, we all know that anything worthwhile naturally takes time.

Remind yourself often that in order to engage your creativity it's essential not to be perfect. It is essential to step outside the box we have labelled 'perfect art'. It is easy to become too attached to our ideas of perfection, fed by expectations, hopes and fears. But let's face it – how can any painting ever be "perfect" as all art is completely subjective.

To be creative is to be willing to live with ambiguity. Not needing problems solved immediately but being able to step back and allow time for ideas to come to mind.

Recognise your thoughts

It is good to train ourselves to be aware of what we are thinking. To recognise when we feel frustrated and what thoughts this brings to the surface. Equally, to recognise when we're in the 'zone' and creativity is flowing out of us like magic. What thoughts occur then? What stories do we tell ourselves? Do we judge our painting harshly? Do we over praise it?

Over-praising a painting can lead to attachment and this in turn will lead to us not being able to move on and fully develop the painting. We can become too attached to a wonderful part of the painting and feel fearful about progressing onto better things. Therefore, as with most things in life, it is good if we can practice non-attachment. It's another one of those ambiguities that we artists embrace. The more we can be passionate and at the same time non-attached to our paintings, the more we are able to be brave and explore our creativity to its fullest.

By getting into the habit of recognising our thoughts we will be able to spot any that are unhelpful or any 'preconceptions'.

'What is important is to keep learning, to enjoy challenge, and to tolerate ambiguity. In the end there are no certain answers.'
Martina Horner

Give yourself the gift
of creating without fear
of failure or expectation of
greatness

These unhelpful beliefs will inevitably get in the way of our creative efforts, so best to try and identify them as soon as possible. The clue is in the name 'pre' conception: it's the thoughts we have prior to fully conceiving our art which can stop us altogether if we're not aware of them. For example, if we engage with our creativity always trying to adhere to some idea about what we 'should' and 'shouldn't' be doing, or if we judge ourselves by our own, usually impossibly high, standards, we will be constantly worried about trying to "get it right" and we won't give our poor old creativity a chance.

Being creative is about learning to let go of preconceived unhelpful beliefs about ourselves and our art. Sounds easy eh? Yes, it is, but first we have to identify what these unhelpful beliefs are, the 'shoulds' and 'shouldn't's', the 'cans' and 'can't's'. Identify them and write them down in your scrap book (or maybe even draw a little cartoon of them...) so they can be easily spotted and dealt with next time they make an appearance.

Engage with your paintings, using your intellect to watch your thoughts, and your intuition to grow your creativity. Learn from them and in doing so develop new insights and ever deeper curiosity about them. Here we are again at the ambiguity that exists at the centre of creativity. The creative

journey necessitates that we take wrong turns along the way. Keep this thought in mind as you go along: *'I am exactly where I should be with the painting'* especially if the painting generates within you a discomforting 'eurgghh' or 'eek!'. Now go with it, explore more.

'The biggest thing that separates people from their artistic ambitions is not a lack of talent. It's a lack of deadlines.' Chris Baty

Make a commitment

We should make a clear commitment to our creativity. Show up at our easel or painting corner and put in the hours. Face our fears. Play. Experiment. Learn.

Here's the truth about all the successful creative people that I know: they work hard. That's their open secret. They don't wait around for 'inspiration' to come knocking; rather, they stand at their easel regularly, ready to work. Even if it they are not 'inspired'. Even if they are dissatisfied with their work in progress.

And they never, ever, give up.

You see, the truth is that 'inspiration' is really just hard work wearing a cape. Please don't be disheartened. The reason you are reading this is because you've felt the breath

of inspiration and you are creative. You have a feeling that you can create something wonderful and you want to have a go. The good news is that you can – absolutely you can. Creativity is in you and you can make it happen. Commit to your creativity. Believe in your vision and believe in yourself.

Creativity is just like a plant; cherish it, nurture it, look after it and it will grow. Provide the right nourishment, water it often and set it in a good position, and you have a good chance of success. It's great to take care of our commitment to our creativity but not to feel bad when we slip. Otherwise negative thoughts and feelings can get a hold and that's when, instead of progress, we can face a downward spiral. If we can be ready and willing to be kind to ourselves, to have a 'relaxed discipline' towards our creativity, this mindset will give us the resilience to get back up when we slip.

Play makes perfect

Play is time spent without purpose, time when we lose ourselves and have some fun. You may have the impression that play is not important, something we engage in during our time off from being sensible grown ups. Interestingly, recent research is suggesting that, conversely, play should be a priority when it comes to our well-being. It's also one

'Inspiration exists ... but it has to find you working.'
Picasso

of the best places – or attitudes – to adopt when we are learning.

And what is this book about if it's not about learning? Keeping a playful attitude whilst painting allows us to try out things without stressing about them or taking them too seriously.

If we can be creative in a playful manner we immediately get rid of all the rights and wrongs and criticising behaviours that are often encountered in an art class. Just think, who ever heard of play being 'marked' 'graded' or judged as 'success or failure'? Exactly.

Approaching learning in a playful, non-judgemental manner will allow us to be easy on ourselves, relax our 'rules', make up new stories and scenarios for ourselves, get back up when we fall and laugh at ourselves. So, take some of that pressure off and put on your magic tutu! In psychological terms, this is called developing self-efficacy. But I prefer the magic tutu.

...and breathe

When we take a deep breath in, we can become mindful, focused and aware of our thoughts.

We can Stop, Look and Listen. I always think of *The Tufty Club* when I mention Stop, Look, Listen. *The Tufty Club* is a children's book we used to have when I was small that encouraged road safety by promoting the simple message of Stop, Look, Listen. A useful guide to creating art too, it turns out!

Often in my workshops people engage so joyously in their creativity that they rush ahead, overtaken by the powerful tide of bringing art into being. In doing so they forget to Stop, Look and Listen and they miss out on so many amazing opportunities their painting is offering them. They become fixated with a deadline, the end of the workshop, wanting to finish their painting by then, so they rush on, reverting to old patterns, and miss out on the pleasure of the process. Here again an artist's ambiguity, the desire to finish a painting needs to be balanced with the relaxed discipline of stepping back, breathing and tuning into our intuition before making the next move. As our paintings evolve, more time will be spent stepping back, away from the easel, to gain perspective both literally and intuitively. The more we feel rushed to complete a painting, the more time we should spend just looking at it from a distance.

Take your time, please don't rush. Your heart knows the way. As you explore colour, line, different paints, different surfaces, different compositions, don't forget to enjoy the journey.

Authenticity comes from attention

All creative works have in common a randomness, making it improbable that two people would independently paint the same picture, ever. No truly creative expression can ever be unauthentic. Finding, developing and accessing your own creative voice is easy, as easy as it is to be yourself. You are one, unique, never seen before and never to be seen again, amazing individual. Only you can paint like you, a true 'one-off' in the whole history of time. Making unique and authentic art is not some mysterious process that takes years of introspection. All it takes is time, commitment and a belief in yourself. And because you are creative, this will be a doddle and you'll have a blast doing it.

'Today you are You, that is truer than true. There is no one alive who is Youer than You.' Dr Seuss

Here's how. Just find the things that you like to look at. Then find some more things you like to look at and then some more. Gather these in your scrap books / sketch books (you're going to need quite a few of these, fortunately there are many really gorgeous ones out there to choose from). Enjoy cutting out what visually turns you on and sticking these into your scrap book/sketch book. Then look some more at what you've chosen, really pay attention. Make a written or drawn note of what it is that has caught your attention

about the image. Is it the shape? The use of line? The juxtaposition of colour?

You see, your authentic, individual, creative voice is not deep within you – it's outside you. It's in what others have seen and found to be amazing, arresting, moreish, inspirational and what they have communicated to you, visually. They are sharing what they have been inspired by for you, in turn, to be inspired. Great isn't it, to think of this thread of inspiration passing along cultures, generations, continents, ending up with you?

You start to paint like you by combining different influences. You can take colour from Klee, line from Mondrian, you can add a splash of Hockney. Mix in a bit thick paint from Van Gogh, a silhouette from Matisse ... the pool of inspiration is almost endless. You pick a little bit from any and every artist you love and then you combine them in a way that makes you smile. This is the real road to authenticity.

All art is made up of these tiny jewels of inspiration and where do they come from? They are 'adored' from other artists' work. You may find yourself resistant to this idea; don't worry, that's just your ego wanting to claim sole credit for a painting. The reality is that all art is a wonderful mosaic of influences and inspirations.

This is not to say that copying or plagiarism is OK; in fact, it's very much not OK and can land you in a lot of trouble. Imitation is not, as the saying goes, the sincerest form of flattery. It is a dull, flat, 2D version of the real thing. Do this and your days at the easel imitating others will feel unsatisfying, contrived. But what is very OK is to learn

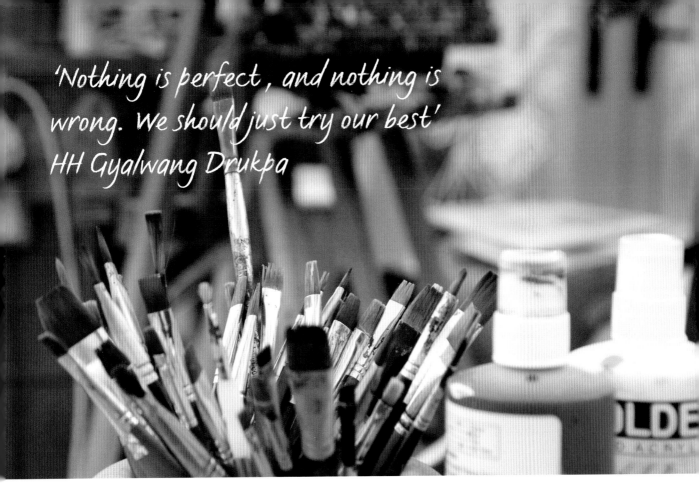

'Nothing is perfect, and nothing is wrong. We should just try our best'
HH Gyalwang Drukpa

from others (just as they themselves learned from others) and from that paint your vision. After you find your voice you'll realise there's really only one person that is worth imitating and that's you. Only you can paint like you and that is very exciting.

Take heart

To me, the notion of 'taking heart' suggests self-discipline, courage and gentleness. It also means developing the ability to live with all the ambiguities that are present when we are creative. The ability to take heart when you commit to your creative journey will mean that you will have a smoother path. You will still experience times of joy and of frustration but you will not be deterred by them.

This is so important. How many people do you know with unfinished paintings? So many potential paintings growing old and dusty in the back of the cupboard. That's so sad. This can be avoided by keeping focus on intention, attention and our attitude. Dedicate a shrine-like space in your heart and home for your creativity. Acknowledge it for the life giving, precious gift that it is. Keep mindful of your thoughts and how you're feeling and a gentle focus on 'relaxed discipline'. Be kind to yourself when inevitably you fall short of the standards you set yourself. And remember, people have been being successfully creative since the dawn of humanity ... it really is a natural process and you can do it too.

Comparison – the thief of joy

Listen – even if, for one moment in time, the painting you created was the best painting ever in the world, it would soon be surpassed by someone else's painting. And someone else's, and then someone else's. You get the idea. So do you see the futility of trying to be 'the best' and of comparing your work with others? Comparing yourself with others has been described as 'the thief of joy', a very apt sentiment. But it's no wonder that we compare ourselves and our work with others. From a very young age we are graded, marked, assessed and compared. Even if you are assessed as 'the best' what then? How would it feel to be 'the best' knowing that you can only ever go one way from there?

There's only room in a day for so many thoughts and feelings and actions. So why not fill your day with appreciation and happiness for what you are achieving? Leave behind the thoughts that cause you anxiety and suffering. Hanging on to these is quite literally a waste of time when you could be painting instead!

Seriously, having an appreciative state of heart and mind will put you in the optimum place to do your best work. No one can produce their best work when their heart and mind is filled with feelings of inadequacy, comparisons and impossibly high standards. Reality check time. I personally would rather be working, creating something 'perfectly imperfect', and enjoying every messy moment of it, rather than complaining my paint wasn't right, envying another artist's paintings or feeling blocked because I can't mix the right shade of green or some such nonsense.

So come on. I invite you, next time you and your painting are alone together, try letting go of expectations and appreciating what is right there in front of you. Enjoy the delicious ambiguities that it has to offer. Relax, be open to your intuitive voice, feel what is right, feel your way forward and just do it naturally. Throw away the stories you may have used about your creativity and act with love and kindness towards yourself.

Gratitude

We are nowhere without gratitude. It keeps us humble, keeps us sane and grounded. It makes the meagre paint-set more than adequate, the hour spent painting enough time.

And blue, what a colour! Just how fantastically amazing is it? Gratitude is surely the feeling we have when we consider the millions of coincidences that must happen for us to see blue... the fact that there is light, the fact we have eyes to see it, the minute chemical changes that occur when we see it. These thoughts only skim the surface of appreciation for our precious lives and the colour blue.

I adore David Whyte's beautiful book, *Consolations* and his closing statement on gratitude. 'Being unappreciative simply means we are not paying attention.' Indeed it does, David, thank you.

'Being unappreciative
simply means we are not
paying attention.'
David Whyte

Your creative toolkit

*'It's not just about creativity,
it's about the person you are becoming
whilst you are creating.'*
Charlie Peacock

Here's what I propose you set about arranging for yourself to begin your creative journey:

- **Some good quality acrylic paint and something to apply it with**
- **Chalk and acrylic marker pens – or a fine brush and ink**
- **Two large canvases, at least 60 x 60 cm in size**
- **An easel, or a nail in the wall**
- **Sketch books / scrap books**
- **A place to work with good light**
- **Patience, commitment and an attitude of gratitude**

This chapter takes a look at the physical tools of the artist's trade – the paints, papers and equipment – everything you'll need to start your creative journey.

Your art supplies

I just love art supplies; paint, crayons, paper, ink, anything I can make art with. They are such a thrill to the senses to browse through, feel and smell. It's easy to visit the art shop and exceed my budget. With this in mind I have recommended a selection of paints and materials for you, chosen from over 25 years experience of buying art supplies. The ones that have made it onto my list are the ones that I believe will be the most satisfying and that will give you the most value for your money as well as delivering great results. (see pages 39 and 41)

If you have a local art shop, I'd encourage you to use them. I'm sure they will be happy to order in any of the supplies from the lists if they don't stock them.

I remember being about eight when my lovely Uncle George (he who had been a desert rat, and in his 70s still sported a rather dapper pencil moustache) presented me with a tin box of watercolours. They were a thrill to

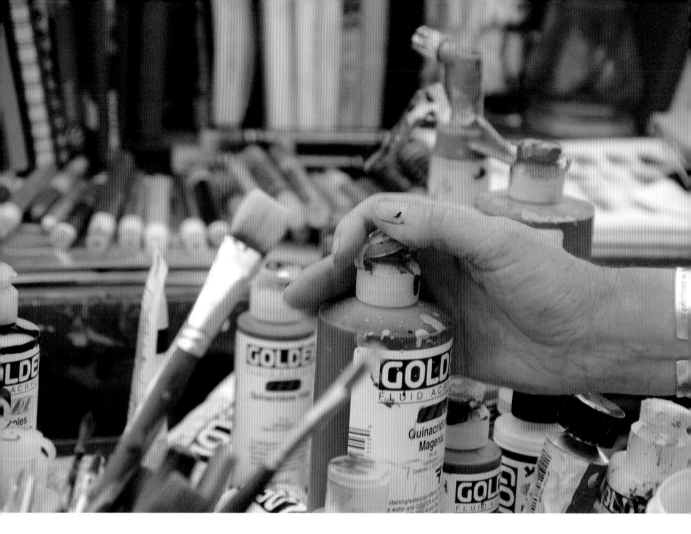

behold! A dazzling array of row upon row of jewel-like blues, fuchsias, turquoises. It seemed to my eight year old self that I was in heaven and held in my hands the key to artistic bliss.

This was in fact the first time I was to experience artistic disappointment.

The colours, when applied with a rough black bristle brush to thin newsprint paper, were lifeless. The paper wore through as I tried to apply increasing layers of the insipid colours to achieve some of the tin's promised lustre.

After 40 years I still vividly remember both the anticipation and disappointment of that event.

Children's and student's art materials are often very disappointing, in terms of colour 'oomph' and quality. I don't understand this – surely it would make sense to give children and students the best colours and materials so they could make a success early? By providing them with inferior quality products we are limiting what they can achieve and expecting results that will go straight in the bin.

So – please do buy the best quality paints you can afford. Buy some of the paints I recommend and some that really draw your attention. They are an investment in your creative life, and as they say, you are worth it.

Acrylic paint

My method of painting focusses on acrylic paints. I love acrylics because they are so flexible. They can be diluted by up to half with plain water for washes, or beefed up with gels and mediums to act like thicker paints. Working in layers, pictures can be painted over and over and over again, which means more chances of getting a painting to 'work'. This means less paintings in the bin and more on the wall, leading to greater self efficacy. In other words, the more chance of success we give ourselves, the more we do achieve. And the more we achieve the more we believe we can do it, and this encourages us to keep trying. Therefore we're more likely to be successful.

But back to the paints for the moment. Acrylic paints are essentially a dye or pigment in a polymer (plastic) binder. They dry fast (about five minutes in a warm room for a thin-ish layer) – so whilst working you'll need to **always, always keep your brushes in water** to avoid them drying out and being ruined. Never allow acrylic paint to dry on your brush or it's bin time for Basil. As this paint has a fast drying time I never put any out onto a palette – I always squeeze or pour the amount I want to use directly onto my brush or onto the canvas. This avoids a lot of waste and protects our environment.

I recommend you wear an apron, or old clothes, as this paint won't easily wash off, if at all, once dry. When dry it forms a plastic film and it's tough stuff. It will wash off your hands – although they may need a nice long soak in the bath to get really clean. A quick note about cleaning brushes. Acrylic paint is not good for our water sources. It's a great idea to wipe of excess paint from your brush onto a paper towel or rag, before rinsing your brush in your water jar. This way less paint gets into our rivers and oceans.

You really don't need a lot of colours – basic reds, blues, yellows and a black and white – because with these 'primary' colours you really can make a world of colour. There's a whole chapter on this exciting prospect later in the book, along with recommendations of which paint to choose.

Keep in mind that not all paints are created equal. Artist's quality paint is sometimes called 'professional' paint' – and the student paint is sometimes called 'basic'. You get the idea. Artist quality paints are made by professional paint manufacturers to specific industry standards for quality, lightfastness, mixability, conformity, stability, performance and colour shift (how a paint changes in colour from wet to dry). Good grade acrylic paint will have the same longevity as oil paint. Today's serious art collector would have no qualms about buying a painting produced with artist quality acrylic paint.

A quick way to tell a good quality paint is by looking at the label. Good paints have a lot of information printed on that small space as they have been through rigorous development and testing; student paints, however, say little about their stability and composition or origin. Using high quality paints will help avoid frustrations, give the best basis for your work and help you to really enjoy the creative process. There's nothing more frustrating than insipid colours, bent brushes and thin paper!

Acrylic paints come in several forms, as Inks, Fluids, Regular or Heavy body, Super Heavy body and Open. Each variant has different properties which makes it more suitable for different applications. Here are the main points for you to be aware of. The rest is down to you to play with and find out about.

LIGHT
GREEN 348

VERT CLAIR
HELLGRÜN
VERDE CLARO

Fluid acrylic paint

Fluid acrylics have the consistency of single cream so they load a brush more evenly than thicker paints. They also flow consistently off the brush allowing for longer, more uniform brush strokes. Many are transparent, allowing for beautiful translucent see-though effects when applied in layers.

These fluids dry very fast, within five minutes for a thin layer. As with all acrylics, once dry they become a water resistant plastic film, which means that when they are completely dry you can paint on top of them with more acrylic. Depending on whether you use a transparent or opaque next layer, you will see the layer underneath and its colour shining through.

Acrylic ink and high flow

High flow acrylic paint is made by Golden, other manufacturers make acrylic inks and both serve a similar purpose. They are the consistency of, well... ink. They have a super high concentrated pigment load in a very thin polymer binder and come in bottles. They are intensely bright and beautiful, especially when dripped onto a dampened canvas. Wow!! They dry super fast too. They readily mix with water and can be applied in very thin washes or directly out of the bottle. Brush, stamp, drip or spray them onto paper or canvas. They can also be used with a dip pen or a refillable drawing pen.

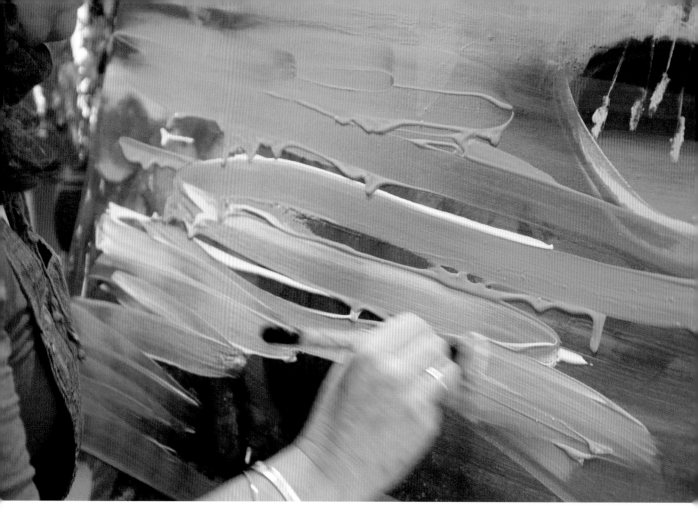

Heavy body and regular acrylic paint

Regular acrylic is what is generally thought of when we think of acrylic paints. The ones you'll see in tubes on the shelves in art stores. Heavy body acrylic paints are thicker and have a great chewy, juicy texture and they glide onto the canvas super smoothly. Extra heavy body is slightly thicker and will hold brush marks, or palette knife marks and will keep its shape when put on in great slabs.

Thinning these heavier paints with water or a purpose-made medium is great if you want to make a very subtle wash of colour.

But if it's thinner paint you require, with full colour oomph then use a fluid acrylic, or an acrylic ink. Thinning down heavy body paint too much will also lead to a lack of adhesion, the little polymer molecules will lose their grip and your paint will peel. You can also thicken up the regular and heavy body acrylics with a medium designed for the job. Most professional acrylic manufacturers produce gels and pastes for this purpose. Pastes and gels can also be used to create textured base layers or added to the paint to thicken it. Pastes tend to dry opaque and gels transparent.

'Open' acrylic paints

Acrylic paints dry quickly. That's one of the properties I really love about them as I can work quickly, adding more and more layers with a creative zest, rather than hanging about waiting for paint to dry. Having said that, if waiting for paint to dry is your thing then fear not, you can still use acrylic paints. There's a whole range made just for you. It's called 'Open' and is made by Golden. These paints have a different, slower drying binder. Same high pigment load, just slower drying. So now, should you wish, you can faff with a layer of paint for a few hours, just like you can with oils. You can also add 'Open' medium to standard acrylics to achieve this effect.

Chalk and acrylic pens

I use a lot of chalk in my paintings, it's my magic ingredient. From marking out my initial compositions to adding final details I use chalk to put my ideas on canvas. Chalk is great because you can make quick, non permanent marks, without the need to commit to them if they don't work. Use chalk to add your ideas to a painting (when the paint is dry) then step back and see if you like the result. If you do, commit to it with paint. If you don't, wipe the chalk off, and start again. This is another great way of working confidently without the fear of 'mistakes'.

Acrylic pens are another vital tool in my creative kit. I use several brands of these for adding finishing details to my paintings. Motolow and Krink brand pens are filled with light, fast, good quality acrylic paint. My personal favourite pens are the refillable 'Aerocolour' from Schmincke, which I fill with Golden High Flow liquid acrylic. If you don't have these, a thin brush dipped in ink or high flow will have the same effect.

Paint suggestions

I personally love **Golden** brand's fluid and high flow ranges with **Liquitex** and **Sennelier's** heavy body paint. They are fantastic top-end products with great painting characteristics and colour density. I also use a lot of **Daler Rowney's** heavy body **Cryla** and their **FW** acrylic ink range. Each of these brands differ slightly in texture and colour. For example Sennelier's Prussian blue is a lot, lot darker than Daler Rowney's. There's no 'standard' colour for a given name, so have a look around and find your favourites.

Choose brands based on your budget, but bear in mind that with 'Artist's Quality' paints you get what you pay for. As a rule, the more expensive the paint, the better quality the pigment and the more intense and vivid the colours. If you can treat yourself, do try some out. But be warned, once you've tried some top quality paint you won't want to go back.

Here's some of my favourite paints:

Golden brand in Teal, Pyrrole Red, Diarylide Yellow, Quinacridone Magenta, Quinacridone Gold, Hansa Yellow Medium, Phthalo Blue (green shade), transparent Phthalo Turquoise, Anthraquinone Blue, Titanium white, Sennelier Prussian Blue.
Oh, and some glitter!

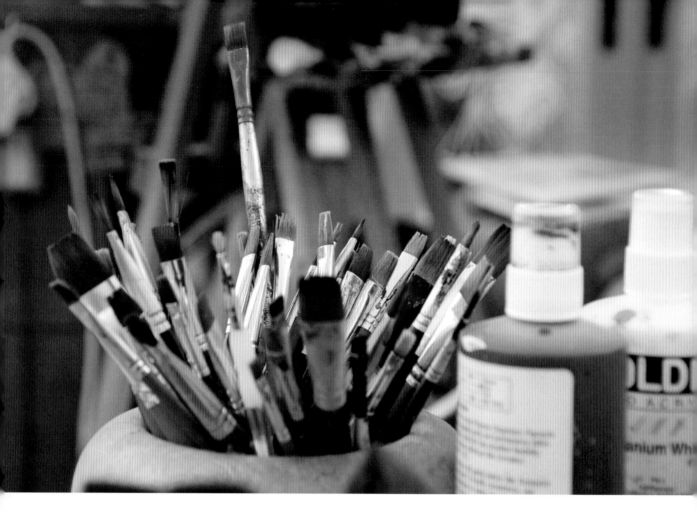

Brushes

Take my advice, when working with acrylics go for a small set of cheap brushes. Acrylic paint is hard on brushes and they won't last long. Save your money for paint.

Look for brushes made for acrylic paint – they are usually called 'synthetic' and have medium firm bristles that are flexible and hold the paint well.

Avoid the white bristle ones, the coarse bristle or 'hog' brushes that are designed for oil-colour application, as these can generate foam bubbles in the acrylic paint because of their rougher bristles, especially if used on textured surfaces such as canvas. The softer, usually dark haired ones known as 'sable' or 'sable style' are generally for watercolour and can be too soft for the thicker acrylics, although these will be great for ink or high flow. In terms of size, you'll only need a couple of the smaller, but not tiny, 'pointy' brushes. For most painting I use and recommend large square-headed foam brushes. You can get these from DIY or art shops. It's a good idea to work with a larger brush on initial layers of your painting to really open the painting up and avoid getting lost in intricate detail too early in the process.

Acrylic paint can also be interestingly and successfully applied using fingers, old credit cards, palette knives, sponges, potatoes... (yes – potatoes! Remember potato painting?)

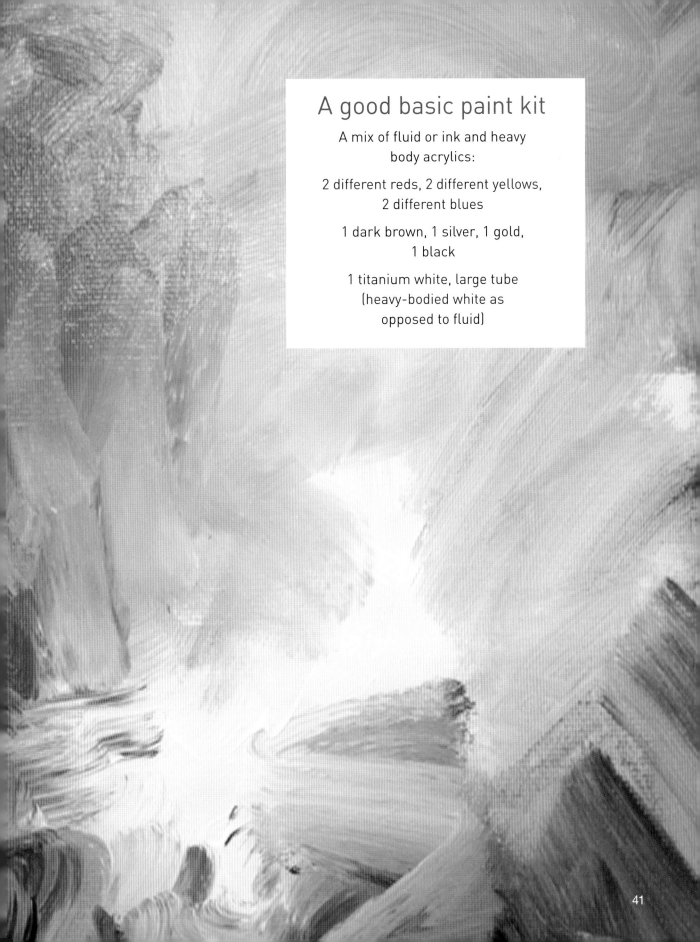

A good basic paint kit

A mix of fluid or ink and heavy body acrylics:

2 different reds, 2 different yellows, 2 different blues

1 dark brown, 1 silver, 1 gold, 1 black

1 titanium white, large tube (heavy-bodied white as opposed to fluid)

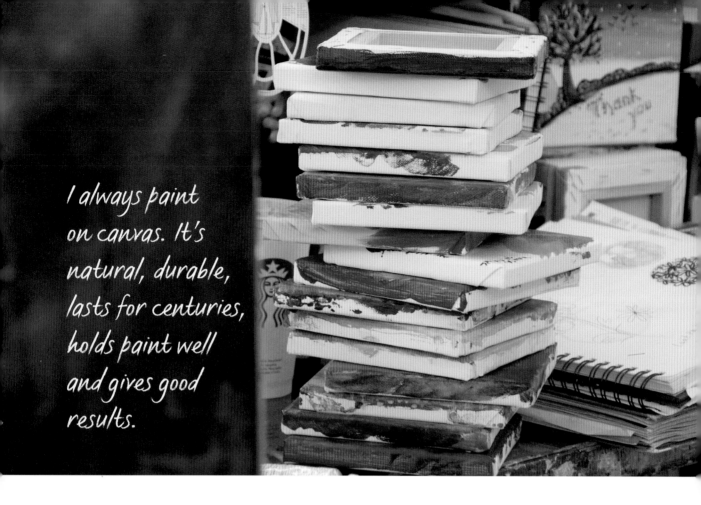

I always paint on canvas. It's natural, durable, lasts for centuries, holds paint well and gives good results.

Canvas

I always paint on canvas. It's natural, durable, lasts for centuries, holds paint well and gives good results. I love canvas because it's so forgiving. After over twenty-five years of professional painting I think I have discarded less canvases than I could count on the fingers of one hand. I just keep on painting over what's there, layer upon layer. If it gets to the point of saturation where paint fails to adhere and slides off, I literally take a steel wool pad to it and some water and rub a layer or two back. Or take a palette knife and use it to scrape paint off and peel back some layers, revealing some lovely colour surprises underneath. There – it's ready for more paint!

Think of how many sheets of paper could have ended up in the recycling bin if I'd been painting on paper – and more importantly – think how disheartened I'd have felt with all of those 'failed' paintings. Now I can honestly say that I almost never end up with a 'failed' painting – I just keep painting over each layer until I am happy with the result.

You will need at least two 60 x 60 cm or larger canvases to start with and as many smaller ones as you want to play with. Size does matter when it come to canvases. The bigger the blank canvas the better – the more room for serendipity to occur. As you'll see when we get to the Techniques section, the first layers of a painting are quite random, when we let the paint give us some ideas of what the painting will be.

The following layers are where we tighten up and begin to coax out a painting. So the larger the canvas you are working on initially, the more room there is to let the paint make its random marks and the more opportunities you'll have for creating a wonderful painting. Be bold – go big!

Canvases come in various qualities. If you want to show and sell your work then you will probably want to buy a good quality make, and here's why:

They will be set square, with proper angled corners. This means no heart breaking problems when you take it to be framed and realise it's not square and looks odd in a frame.

The quality of primer used in manufacture means the paint stays put on the surface of the canvas. Primer is the initial layer of paint put on a canvas before it is sold, usually white paint, which prepares the canvas to receive the paint. Sometimes some of the cheaper canvases I've seen have very dubious primer on them, almost too shiny for paint to adhere to.

If the canvas is too thin, or the primer ineffective, the paint will seep through to the back of the canvas. Interesting, but what a waste.

Good quality canvases have a reassuringly solid feel to them, the material is stretched tight and drum like. They are just such a pleasure to work on.

An easel

Good quality paints were one thing that revolutionised my painting. The second thing was receiving a beautiful, sturdy, full size, hardwood easel for Christmas one year from my lovely dad, something I hadn't asked for as I didn't know I needed one. I'd painted on the dining room table for as long as I could remember.

Using an easel is the most liberating experience. It says 'this person standing in front of me is an artist.' This immediately gives a legitimacy to our art, which in turn encourages us to paint more and, as we paint more we learn more. We can also work on bigger canvases which allows for more serendipitous moments to occur and for us to be braver and bolder in our creative exploration.

Working at an easel makes it easy to remember to step back often, so we gain perspective, literally and intuitively. The painting stays at eye level, where we can see it and keep it in mind, thus allowing our inspiration to engage freely with the work. Also, you really can't ignore a piece of half finished work on an easel, it's there right in front of you. Work on a table and it's out of sight, out of mind.

Finally, in this 'why I love my easel' essay, is the fact that working standing up, rather than seated, is so much healthier for us. We move more and breathe more freely than when seated, which oxygenates our bodies

and minds and enhances both thinking and creativity. Next year's Christmas list...?

Scrap books / sketch books

I used to urge my students to always keep a sketch book. Urged them most insistently to develop a regular habit of always noting down what caught their imagination, what appealed to them, what sparked their interest, captured their attention.

I did this because I knew myself how vital sketch books are to accessing creativity and inspiration whenever it's needed. I didn't realise that for some people it could be a challenge. Until one day a brave person confessed to me in a workshop that he was terrified of his sketch book. "Does it bite" I wondered, and asked him to explain why.

He said that he felt pressurised, by himself, to come up with something interesting and 'worthy' for his sketch book and he didn't feel his sketches were up to it. He didn't feel his sketches were up to the job of inspiring him and informing his paintings. I can indeed imagine that it's a big ask of a humble sketch book!

So after some thought, some looking through my own sketch books, I came up with a way to take the fear out of sketch books simply by renaming them. Their new name was "scrap books / sketch books". Quite simply, it is a scrap book with sketches included, should you so wish.

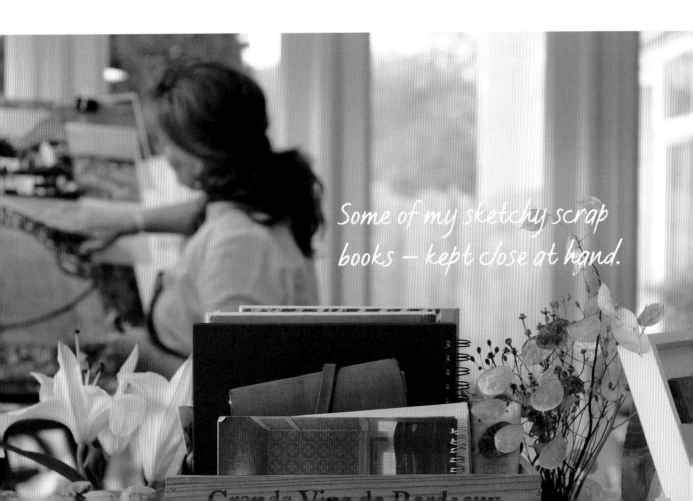

Some of my sketchy scrap books — kept close at hand.

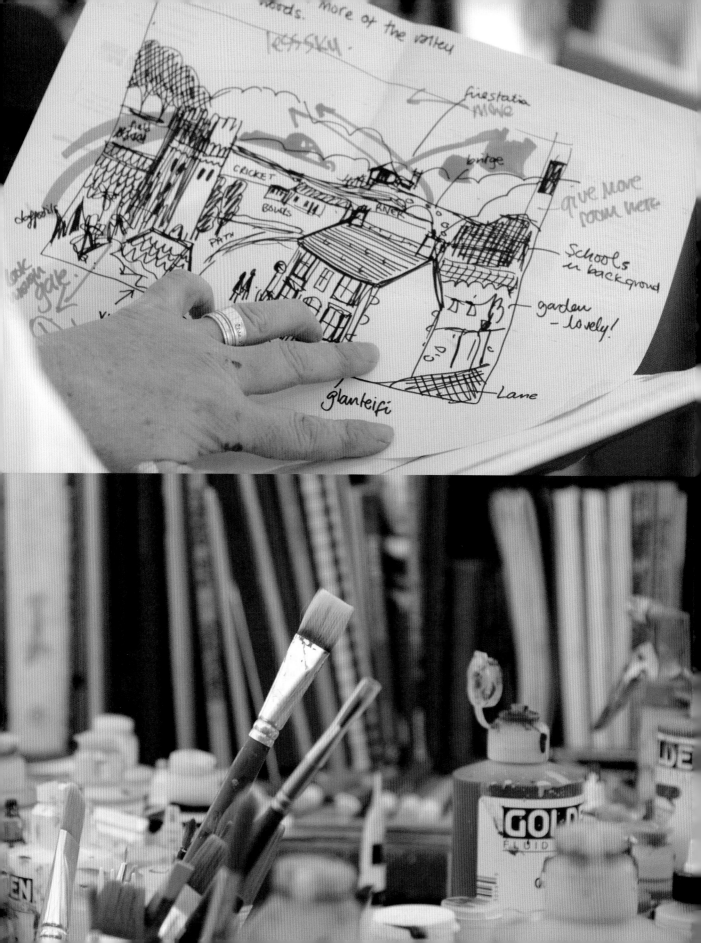

'You need three things for paintings: the hand, the eye, and the heart. Two won't do. A good eye and heart is not enough; neither is a good hand and eye.'
David Hockney

This did indeed seem to take away the expectation (and therefore the fear) from students of thinking they had to produce something 'worthy'. And so the students bounced in the next day, scrap books / sketch books bulging with creative inspiration.

Find an empty book of any shape or size that appeals to you. In fact it doesn't have to even be an empty book. In the past I've 'repurposed' old poetry books from a second hand stall when I was caught short without one. Into this book you sketch, draw, paint, write notes, and do some cutting and sticking; yes, stuff it full with everything that pleases you, interests you, catches your eye and holds your attention. And don't judge it. It will come in very useful later. These books become an invaluable treasure trove of what inspires you – and only you, for they are unique to you.

A personal workspace,
no matter how small,
is very important.

Like a built up mosaic of you, added bit by bit, bright, sparkly piece by bright, sparkly piece. Start filling these books as soon as possible and don't stop. Big books, small books, lined books, coloured paper books, cheap books, souvenir books, fancy books... any book you like, just fill it.

I know some folks like to use their phones or tablets as a visual storage facility, swiping bits of visual imagery from Pinterest and other sites. This is all well and good if all you want to do is look and swipe. The really creative, and therefore fulfilling, part comes when you look at an image that excites you, explore your feelings and become further engaged with the image. Then you look even more and analyse why it's caught your attention. Then you reproduce the elements that have your attention in your book. As you sketch them you get to know them, the feel of the shape, the flow of the lines. Just sketch the elements that have your attention, no need for perspective or a whole scene. Again, this facilitates easy access to creativity, by removing the blocks associated with drawing skills.

I encourage you to sketch out the elements that catch your attention, in order to get to know them; for your brain to process them, for your hand to familiarise with them and for your heart to enjoy them. A swipe file on a tablet or phone is never going be any more than a swipe file. No eye, no hand, no heart = no art.

You will need these books later when we get to the actual painting bit, which we will soon – I promise!

A place to work with good light

A personal workspace, no matter how small, is so important. You really need somewhere you can place your paints, scrap books / sketch books, and a vase of flowers. Look and see where you can carve out a corner just for you and your creativity into your living environment. This may mean moving some furniture around. Think creatively.

Setting space aside for your creative journey means you don't have to put your materials away after each session, so you're more likely to be able to jump into it whenever you have some free time. You are also more likely to stick to the time that you've scheduled in your diary. There's no deterrent like having to get your creative kit out each time you want to paint and then having to put it all away again. Too sad.

Once you've got your niche, just a small table somewhere will do, make it yours. Take your easel (or nail in the wall), paints, brushes, water jars, scrap books / sketch books, pencils, and make your intention clear by placing a small vase with a flower or two on your work space. Honour that space, invite inspiration along to visit, and be grateful. Even if what you have is a camping table and a folding chair, be grateful.

Next you'll need some light, not necessarily daylight, just something reliable and constant. When I first became obsessive about painting (I was going to write 'serious' but that would not be true and it also suggests I made a choice. No, I became obsessed); as I was saying, when I became

Patience, commitment and an attitude of gratitude are the essential parts of your creative toolkit that you will need in abundance to blossom into your wonderfully, uniquely creative self.

obsessed with painting I was holding down a full time professional job, running a home, bringing up two children and caring for a sick relative. We were not well off, always trying to make ends meet and never quite managing.

I worked at my painting when I came home in the evenings, often after 8pm. I couldn't afford expensive daylight bulbs so I used a large 500w lamp – wow, that lamp gave off some light (and heat). It still does, I still use it as it's my favourite source of light. The point here is that the lamp was not ideal, it was (is) way too bright for me to tell accurately the colours I'm using. But I like that – I've got used to it. And in many ways I am grateful that I could only paint in the evenings, often in the dark, by this strong strange light as it gave my paintings a different feel – I guess it made me paint in stronger colours which as it happened were the colours I loved.

My lovely old lamp, it's reliable (mostly) and it's consistent, which means I paint in the same light each day. This gives uniformity to my paintings and experiments. It's old and cranky, unlike me, but it creates my workspace and I love it.

Patience, commitment and an attitude of gratitude

I left this until last on the list as it is the most important item of your creative toolkit. I'd like you to take these words as a gift – the best present I can give to you – to help you on your creative way.

You may have the lovely paint, the easel, the studio and the light, but have you got the patience, commitment and an attitude of gratitude? I hope so because these are the essential parts of your creative toolkit that you will need in abundance to blossom into your wonderfully, uniquely creative self.

'Colour is everything.
When colour is right,
form is right.'
Marc Chagall

Colour

*'When I haven't
any blue I use red'*
Picasso

The colour wheel – an introduction

Understanding the colour wheel and colour theory is a life-long obsession for many painters but it need not be complicated. It is however a very important tool for you to know how to use, if you are to get the best results with your paintings.

What I say here is what I have found to be useful, it is by no means 'The Law'. There are as many approaches to colour mixing and theory as there are artists. I've put together what I have learned through my own experience and offer these guidelines to get you started and to give reliable results.

When you are confident with colour you should carry on, choose your own colours, mix your own colours and continue to learn. There's always a new colour and a new colour combination to find and fall in love with.

Here's my guide to simple colour mixing. How to get the very best results from just a few paints and how to avoid a huge amount of waste and a considerable amount of frustration. Understandable as there are over 100 different colours available in acrylic paint alone, each with their own chemical dye or pigment make-up. Some blues lean towards the red spectrum (Phthalo Blue Red Shade for example) so this is not a great choice for colour mixing. Why? Well because, as the name suggests, it's got red in it and therefore will make great purples when mixed with red, but poor greens when mixed with yellow as that would be mixing the three primaries, which will make mud.

I know, it can be confusing. But fear not, let's wander gently back into the realm of simple colour mixing.

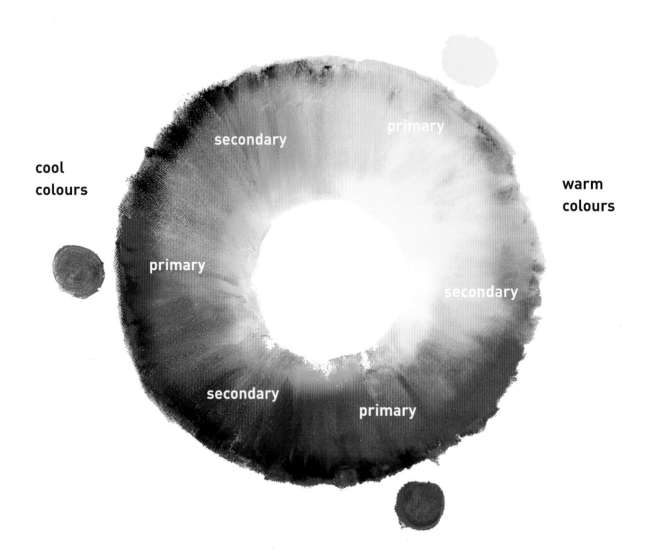

cool
colours

warm
colours

secondary

primary

primary

secondary

secondary

primary

Easy mixers

You need to know that **primary colours** i.e., the yellows, blues and reds are the ones that cannot be made by adding any other colours together. These are the bones of your colour kit. These primary colours come in many different shades, some are true primaries and will give excellent results. Others, because of their pigment make-up, will make muddy, dull colours. Use the ones I recommend for great results.

You only need the three **primary colours** of **magenta**, **cyan** and **yellow** – and of course black and white to make a very pleasing spectrum of colours. The colour wheel I painted to illustrate this section was done using these five paints, and just look at all those juicy colours!

Yellow

Cadmium Yellow Light is the best primary yellow for mixing – but it also contains a heavy metal so is not recommended for children's use or unsupervised adults. Always treat cadmium colours with caution. They are lovely, but toxic. It is recommended that if you use cadmium based colours you avoid skin contact – and don't eat the paint!

'Process Yellow', 'Primary Yellow', 'Cadmium Yellow Hue' and 'Hansa Yellow' are the ones to look out for and use.

Magenta (Red)

Most of what we tend to think of as red is in fact classed as orange when it comes to colour theory. Don't worry – the 'red' you want is called Magenta – it looks more purple than the classic 'blood' red.

Magenta is the purest red, and will mix well with the other two primary colours of Cyan and Yellow. Look for 'Process Magenta' or just 'Magenta'. My own favourite is 'Quinacridone Magenta'.

Cyan (Blue)

Cyan is a lovely bright blue. This blue is chosen because of its clarity of colour and ability to mix well. Look for it in most paint ranges. 'Anthraquinone Blue' is my favourite, although it's quite dark it's a good mixer.

There are so many shades of blue paint available and each will have a slightly different chemical make up. Some of the shades will lean more to the red spectrum – and so will mix excellent purples when added to red, but will make muddy greens when added to yellow.

Black and White

You'll also need black and white paint for tinting, shading and toning your colours, making them lighter or darker. If you make colours lighter by adding white, the result is called a **tint**. If you make them darker by adding black it becomes a **shade** of the colour, and if grey is added the result is a different **tone**.

If you doubt that you can make a rainbow of juiciness with only three colours, think for a moment about the colours that are used by a standard 3-ink desktop printer and look at the spectrum they achieve. If they can do it, you can too.

Please Note: Mixing other colours (e.g, orange, purples, greens) into these three primaries will dull their vibrancy. Avoiding doing so is your key to achieving excellent, clear, and eye-catching colours, thereby creating confidence in your own abilities. The addition of glitter at any stage is, of course, to be encouraged!

Always keep your cool colours and your warm colours separate.

Warm and Cool colours

Sorry to go on, but this bit is important. Warm and cool colours. Sounds simple? Well, yes it is, get this right and your paintings will never have any dull grey places – unless you so choose.

Warm colours – like a fire – reds, yellows, oranges. These colours will come forward visually on a painting.

Cool colours – like ice-blues, turquoises, greens, purples. These colours will recede visually on a painting.

Always keep your cool colours and your warm colours separate. When you are starting out, whilst painting try to have separate palettes (if you use them) and separate brushes for warm and cool colours. Keep your water really clean too, to avoid muddying the colours.

Always make sure that a layer of cool colour paint is thoroughly dry before adding any warm colour paint, and vice versa. This will keep your colours fresh and bright.

You can mix any of the warms together – on your palette or on your canvas, and likewise any of the cools with themselves. But never the twain should meet in their wet state.

Unless you like mud.

Colour fun and mixing theory

Here's a quick and fun way to get to know your paint. This experiment has the added bonus that you can use the canvas later as the basis for a painting. Enjoy!

1. Start with a brand new, white pre-primed canvas, 40 x 40 cm in this case but any size will do – in fact, the bigger the better.

Here I'm using three of my favourite primary colours – Anthraquinone Blue, Dairylide Yellow, and Quinacridone Magenta in heavy body acrylics, along with white and black in fluid and high flow acrylics. You could use all heavy body or all fluids, or a combination.

2. Squeeze out a few centimetres of the blue, yellow and magenta – roughly evenly spaced on the canvas. Next, add a squeeze of white into the centre for mixing into the colour to change the tint – to lighten the colour mix – and to show just what variety can be made. Add black, literally one drop, into each outer corner to be blended in carefully to darken the shade. Just remember, you can always add more black but you can't take it away, so gently does it!

You'll need to work quite quickly to facilitate paint mixing before it starts to dry. That's why I use so many brushes, so I don't need to spend time cleaning them between colour changes. If the paint does start to dry, add just a small amount of water with your brush.

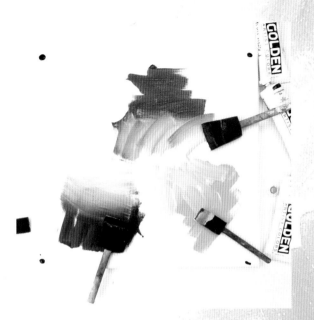

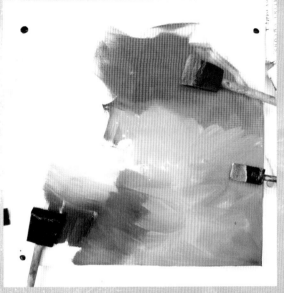

3. Reach for a clean brush and dip into the white and begin blending outwards into the yellow, magenta, and finally blue. Use a clean brush for each colour to keep each colour strong and un-muddied blending the white outwards from the centre. Adding white to the mix really makes the colours come alive.

4. Using separate brushes spread the different colours out. Pick up a tiny dab of blue on your brush and start blending into the very edge of the yellow to begin making a whole range of greens. It's suprising how little of the darker colour you'll need when mixing colours – in this case the blue is darker – to alter the lighter colour (yellow) so take it slowly, a little bit at a time.

Just remember, you can always add more black but you can't take it away, so gently does it!

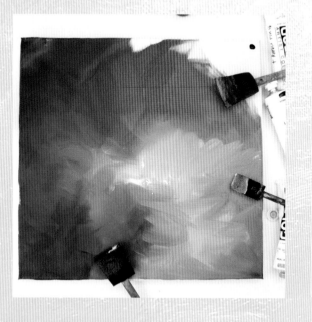

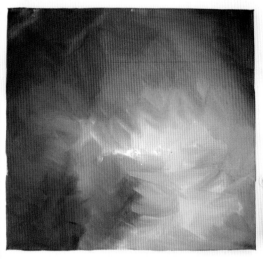

5. Then begin to blend the yellow and magenta. By mixing the primary colours yellow and magenta you'll create a secondary colour – orange. Now begin to blend the blue and magenta in different ratios. By mixing the primary colours blue and magenta you'll create secondary colours of violet and purple.

Very cautiously blend in the smallest speck of black in the outer edges of your colour to experiment with darkening the shade.

6. Take the finished colour wheel, let it dry, and use it as the underpainting for your next masterpiece. If you'd like to explore colour mixing further, try painting these loose colour wheels with different reds, blues and yellows. You'll be surprised at the results and this experiment will allow you to find what colours really resonate for you.

Try these mixtures for great results:

Historical Hues: Smalt Blue, Naples Yellow and Alizarin Crimson – a classic 'old masters' palette. **Modern Colours:** Hansa Yellow, Naphthol Red, Anthraquinone Blue. **Fluorescents:** Chartreuse, Blue, Magenta.

If you'd like to explore colour mixing further, try painting a colour wheel with different reds, blues and yellows. You may be surprised at the results.

Quick recap

Primary colours – magenta, yellow, cyan. Mix any two to make a secondary colour. Mix all three to make dull greys and browns.

Secondary colours – orange, purple, green are made by mixing two primaries. Mixing any two secondary colours will make greys and browns.

Warm colours – yellows, reds, oranges.

Cool colours – blues, greens, turquoises.

Always keep your cool and warm colours separate to keep your colours vibrant and full of life.

Using colour schemes

Applying a colour scheme to a painting is an easy and effective way to get your paintings to 'work'. By applying a cohesive colour scheme to your painting you'll be giving it every chance of being a great painting. You know how sometimes when you look at a painting and something just isn't right with it? Sometimes it's balance, sometimes line, but usually it's colour. Here's my simple way to success with colour.

On the following pages are three of the most widely used colour schemes in art. Have a look at a well known painting and see if you can identify which colour scheme has been used. Bear in mind that the schemes you see here are the full on, hi-fi, undiluted forms of colour. They are not toned, shaded or tinted down with the addition of white, black or grey. Not many paintings are completed using colours that have no white or black added to tone them down a bit (well OK, some of mine maybe...)

Have some fun playing with these colour schemes and seeing the visual impact that applying a scheme has on our paintings. It may look daunting at first, but it's really quite simple once grasped. Applying colour schemes to paintings is one of the biggest lightbulb moments for many of my students. I hope you enjoy it too.

Left: Complementary colour scheme painting.

Complementary colour scheme

Complementary colours schemes use colours opposite each other on the colour wheel. Purple with yellow, orange with blue, red with green. Interestingly if you mix two complementary colours you'd get greys – sometimes useful for shadows and passages of the painting you wish to recede – that's useful to remember.

Complementary colour schemes make a very powerful colour statement which can be a little overwhelming.

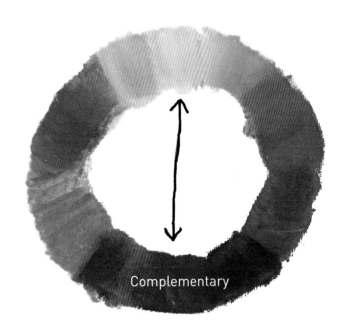

Complementary

Analogous colour scheme

Analogous colour schemes are based very much on what you find in nature. They tend to be harmonious, calm and balanced. They consist of colours from any quarter of the colour wheel. In this example you can see the cluster of arrows point to turquoise, through the green hues to yellow, with one arrow pointing directly opposite to the magenta. This opposite 'splash' of colour is what will really fire up this colour scheme. All analogous schemes use this 'splash' of colour. For example, if using the quarter of the wheel from mauves, purples into cyan, adding a splash of orange will make the painting come alive.

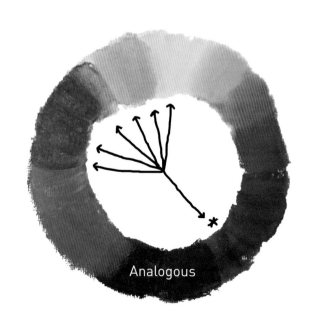

Triadic colour scheme

Triadic colour schemes tend to be quite vibrant, even if you use pale tints of the colours.

The triadic scheme, as the name suggests, refines the painting into three main colours – all equally spaced around the wheel. The illustration shows violet, blue, yellow/orange. Equally you could have red, lime green and green/blue. Or green, orange, purple.

To use triadic colour schemes successfully, pay attention to balancing the colours – one of your three chosen colours should dominate and the two others should be used for accents.

Right: Analogous colour scheme painting.

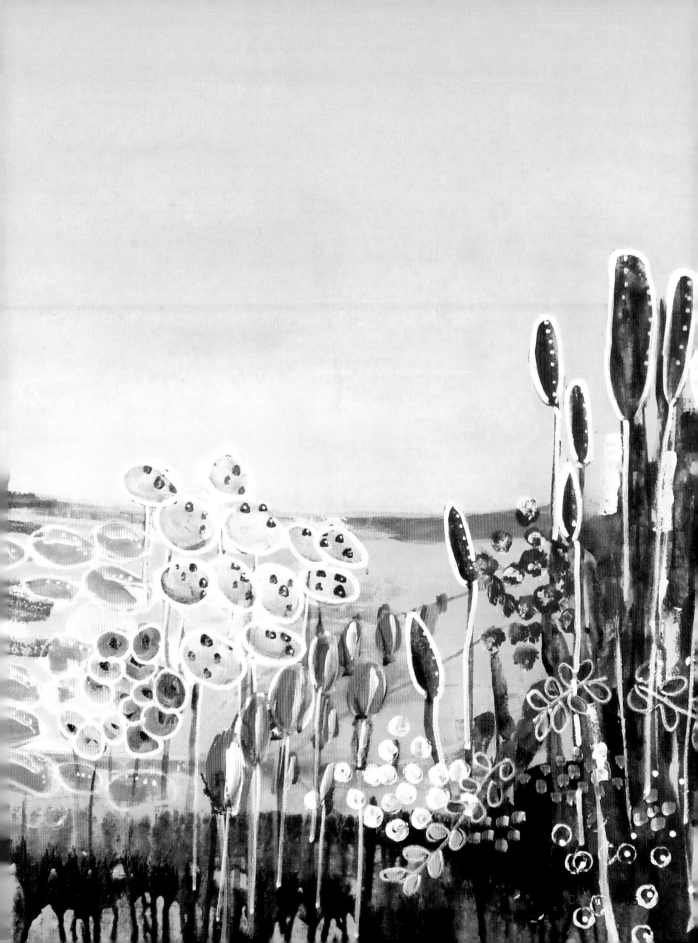

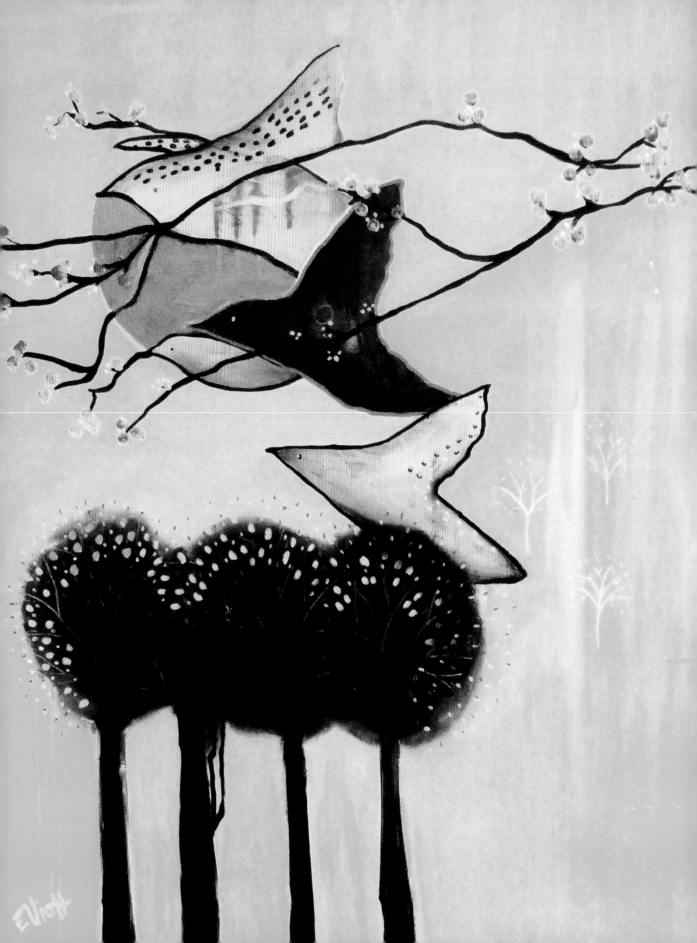

We'll be looking at applying colour schemes to our paintings in further chapters. But before we get to that let me introduce you to some of my favourite paints. They don't exactly fit into any colour wheel ... as you see, I've saved the best until last.

Sparkle and shine

Here they are, the stars of my show – the shimmering, iridescent, interference and metallic paints. Remember with these, as with everything in life, play makes perfect. Arm yourself with some of these 'super-paints', experiment and have some fun.

I've left these beauties until last, as that's when you should apply them to your painting for the greatest effect – during the last layers.

Iridescent and interference colours contain teeny, tiny mica flakes, coated with a super thin layer of paint. They reflect and refract the colour, synthetically reproducing natural phenomena – the effect of light on fish scales or a butterfly's wing, and the shiny and reflective qualities found in metals and minerals. WOW! What about that – a whole new dimension you can add to your painting.

Interference, iridescent and pearlescent paints are almost see-through when used alone. The important thing to remember about them is not to take them at face value, they are not as they appear straight out of the tube. Their true colours only shine

when you learn to apply them with other colours, or when you paint them in a very thin, transparent layer onto a dark surface. Transparent colours can be mixed into iridescent or interference colours to produce other interesting results.

To achieve the brightest colours with the interference paints, add a super small amount of black, 1:100 or less. Using this tiny amount of black will strengthen the reflected colour. To get the best from iridescent colours, avoid mixing them with opaque colours, matt mediums or gels. Conversely, adding a small amount of gloss medium or gel increases the spacing between pigment particles, maximising the effectiveness of each reflective pigment.

OK, now you know all that you need to know – for now – about acrylic paint mixing and colour theory. Let's get on and do some creating!

Left: Triadic colour scheme painting.

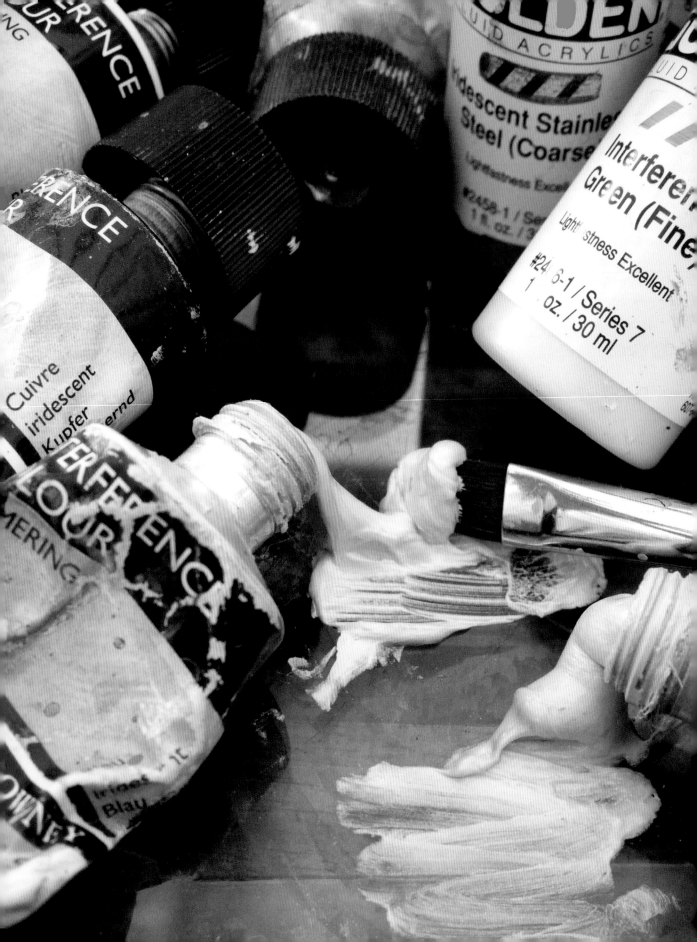

The 'Creative Me' method of painting

'Ultimately you must forget about technique. The further you progress, the fewer teachings there are. The great path is really no path.'
Morihei Ueshiba

Disclaimer: I never went to art college. In fact at age thirteen I was asked to leave the art class. Although art, and colour in particular, were my passions, I didn't fit into what was required. So, being convinced that I 'couldn't draw' I left to study science and I'm so very glad I did. I love science too. But not quite as much as I love art ...

Therefore, what I'm going to say in the following pages about painting techniques I literally made up as I went along. It's what has worked for me. I have read books, talked to artists, looked at thousands of paintings, but most of all I have learned from experimenting ... just like in my science classes. Based on these experiments I've come up with some ideas for you to try. And some suggestions of what may be helpful to avoid.

What I am excited to share here with you is the way I worked out not only how to paint,

there are hundreds of guides for that, but also how I overcame the unhelpful thoughts and beliefs I had about myself as an artist and about my own creativity. As I said I lay no claim to any 'correct' way of doing things.

'If I create from the heart, nearly everything works; if from the head, almost nothing.' Marc Chagall

Indeed I sincerely doubt that there is any 'correct' way to paint, and if it is claimed that such a thing exists then I am certain that in terms of creativity, it will lead to a dull, dead end. Which is the exact opposite of what I hope will open up to you very soon.

As we move along this creative journey you will begin to notice...

- More ways of accessing your creativity
- More about yourself – and what inspires you
- More of your thoughts – what encourages you and what holds you back
- More of your creativity – and how to nurture it
- More of your authentic self
- Oh, yes and more ways to apply your paint.

And so to begin

Firstly gather your materials. These have been fully explored in the chapter 'Your creative toolkit'

- Your two large canvases. I suggest you start with ones that are at least 60 x 60 cm, the bigger the better. Smaller canvases can compound our apprehensions, bigger canvases allow for many more beautiful passages of paint to spontaneously occur.

- A basic set of acrylics, in a mixture of both **fluid** and **heavy body**, any colours you like but make sure you include: two reds, two yellows, and two blues, a black and a white.

- Sponge brushes and the technical 'pointy brush'.

- Chalk, pencils, pens, markers, stamps, stencils, crayons or oil pastels, to embellish your painting with.

- Your scrap book / sketch book.

- Baby wipes, kitchen roll and a large pot of clean water.

- Garden/plant spray bottle, full of water... don't add any soap as soap will react with the paint and could lead to peeling.

Start with Yes.

I believe wholeheartedly that an artist does not need to know much. Being creative is a process as natural as walking and talking. Yes, it takes some practice and yes you'll fall over or talk gobbledegook whilst you learn... but it is a natural process that everyone can do. As a student said to me, if children got disheartened when learning to walk every time they fell over, then we'd all still be shuffling around on our behinds. She's right. So trust yourself, go with the process and have some fun, enjoy the falls, get up again, find your balance and move onwards!

I love this quote from Picasso: *'Every child is an artist. The problem is how to remain an artist once he grows up.'* It's back to that room full of enthusiastic five-year-olds again. So with that thought, and bearing in mind that you were that child once upon a time, shall we begin?

The first layers, letting the paint decide

The first layers are the easiest. Trust me, I'm an artist.

The very first thing to do is let go of your expectations of what the finished painting will be. It's a huge ask to have the fully formed vision of your painting in your head, the million or so tiny brush stokes, the thousands of hand, eye, heart decisions that will be made as the painting progresses. Nigh on impossible. So do yourself a favour. Get rid of any preconceived ideas or expectations about what the painting will be and try just letting the paint decide.

Begin your paintings as I do and there will be no more staring at a blank canvas waiting for inspiration to show up. Just get in there with some fluid acrylics or acrylic inks and start with 'yes'. Be guided by the simple steps on the following pages and you can set sail on your creative voyage, a confident sailor.

Start by spraying both blank canvases with a little water, then drip some fluid acrylics or acrylic ink into that water. On one canvas use

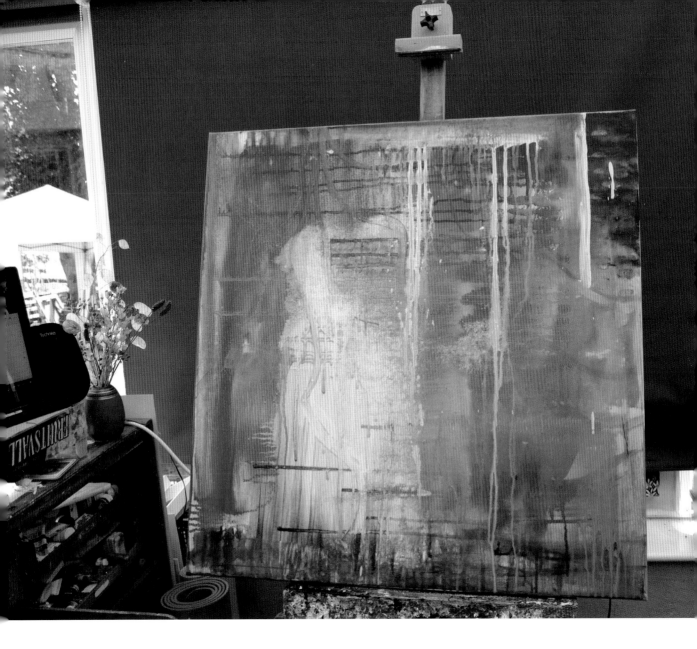

cool colours, on the other warm colours.

Cool colours are all the blues, turquoises and greens.

Warm colours are your reds, yellows, oranges, pinks.

You don't need much of these fluid acrylics or inks. They have the same density of pigment as standard tube paints, but in a fluid suspension. This makes them surprisingly punchy and beautifully vibrant. Note that you won't get the same beautiful vibrant colours with watered down heavy body paints. This is because you'd be watering down the pigment too and you'd get wishy-washy watercolour effects. OK for some paintings, but not for these.

Move these layers about either by moving the canvas around to make the paint run, or moving the colours around with your fingers or a brush. Or both, feel free!

Remember: always use separate layers for cool colours and warm colours.

Allow this layer to dry completely, in the air or with a hairdryer, before you move onto the next layer. This way you will keep your colours vibrant and bright. When each layer is thoroughly dry the water in the paint will have evaporated and the plastic binder in the paint will have bonded together, locking in the colour particles forever. It will have formed a non-porous, water resistant skin, so you can paint subsequent layers on top, which, depending on the transparency of the next paint you use, will allow the colours of the previous layers to show through. Some of the media that I work with has been developed to maximise this transparent property of acrylic paint, to wonderful effect. These include gels, interference colours and iridescent colours. Details of these lovely paints can be found in the 'Creative Toolkit' section.

Working in translucent layers is the secret and the beauty of painting successfully with acrylic paint. Now apply your second layer, cool colours if you used warm for the first layer, or warm if you used cool.

Move the canvases around again, top to tail and round about, allow the paint to decide its patterns, let the colours drip and run and maybe add a little more water. Mark into the wet paint with a finger, brush or stamps. There's no right way up for the canvas at this stage, it's far too early to impose on these

Working in translucent layers is the secret and the beauty of painting successfully with acrylic paint.

newly born paintings an identity. Write words or draw shapes into the wet paint... have some fun!

Enjoy the paint, the textures, feel and smell, yes, different colours do have different scents. Try to be fully present in the process. Now may be a good time for a cup of tea. Remember throughout all these steps to Stop. Look. Listen. Pause, step back and really have a good look at the painting. Enjoy the ride and let your intuition speak. There's no rush. Take your time. Look for parts of the

painting that are interesting for you.

Let these lovely first layers dry completely, before repeating the process with another layer of fluid acrylics or inks. Repeat this process until you feel you want to move on, two or three times on each canvas is great. Just make sure each layer is completely dry before adding another layer. And yes, it should look like a mess!

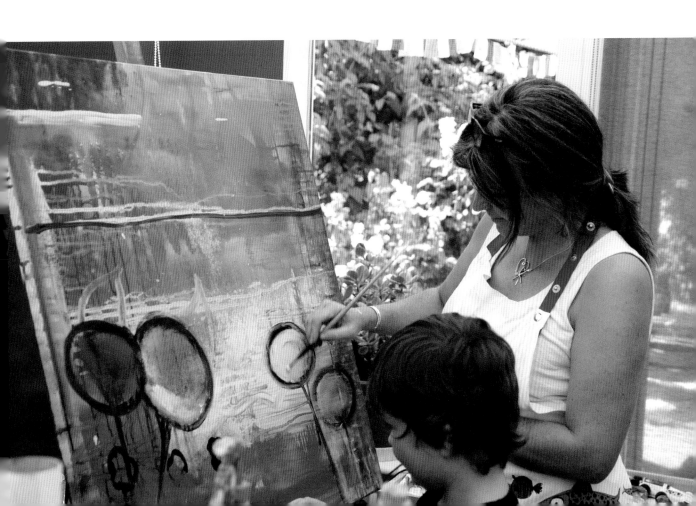

Dark darks and light lights

In order to really stand out, paintings need areas of high contrast. Black and white are the highest 'value contrast' colours, so by randomly adding areas of black (or another really dark colour) and white you'll be sure to have areas that 'pop' in your finished work.

Time to add some black paint and some white paint, each in a separate layer. Heavy body or fluid. Two more layers. Again, ensuring each layer is completely dry before starting on the next.

Continue to make whatever marks please you with a wide brush, fingers, stencils, stamps. Drip and dribble again if you wish. Again, make sure each of these layers (one white, one black) are totally dry before you add another. If you find making random marks challenging, ask a child to help ... they'll show you how in no time.

Keep your mind and your work adventurous, playful and fun.

Remember we're working on two canvases? This is because if we run out of enthusiasm for one we've got the other to jump straight into.

A note about black and dark colours: you can use black right from the bottle – as I do – or, if you prefer, with the colour mixing experiment from the 'Colour' chapter in mind, you can use any colour with a fair amount of black added to make it inky and dark.

Choices and changes

You should be getting an idea of the versatility of this lovely acrylic paint by now. So let's have some fun.

Refer to your scrap book / sketch book. Flick through and alight on a reference that your attention is drawn to today. A word? A colour? A shape?

Sometimes in our scrap books / sketch books we have included beautiful scenes, maybe a river, a harbour, a sunset. Rather than trying to impose the whole of the scene onto your painting, look carefully at that scene and identify exactly what it is about it that has attracted you to it. Is it the interplay of blue and gold on the water? The simple yet strong shape of the reeds? These are the elements that have resonated with you and these are the ones to introduce into your painting.

By observing, isolating and finally incorporating these elements into your painting, layer after layer, you gradually start to build up something truly unique to you. Something made up of all the colours, shapes, words, patterns and symbols that have inspired you and held your attention. And you can be absolutely certain that no-one in the whole wide world will use these inspirational cues exactly the way that you will. It's a kind of magic.

Use chalk to mark on your canvas where you like to add your ideas. Using chalk on dry paint is a great way to put down your ideas to see if they work, before committing to them in paint. Use the chalk to roughly sketch in some shapes, then step back and stop, look and listen. If your marks look and

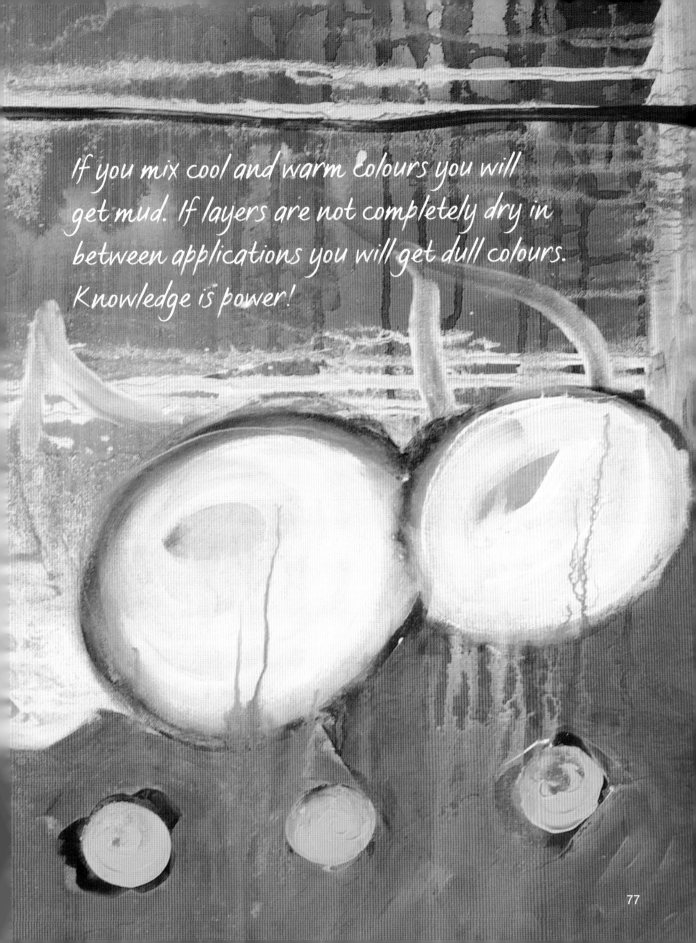

If you mix cool and warm colours you will get mud. If layers are not completely dry in between applications you will get dull colours. Knowledge is power!

feel interesting to you, grab your paint, any colour that gets your attention and start transferring your marks onto your painting. Want to do another? Do it again, go for it.

Here's a tip ... if it feels good, do it again. And then stop when it stops being exciting for you. So if that blue and gold interplay felt fantastic to paint, do it again... if the sharp outline of a reed shape satisfied you, do it again. Really try to get in touch with how it feels to put your chosen colours and lines onto your canvas. Your creative intuition speaking loud and clear to you. Your job is to listen to it and to trust it.

Letting go

So maybe by now you have some lovely passages in your painting, bits you look at and think 'ahhhh' and other bits you look at and think 'eughhh' (or something similar). Great!! This is exactly where you should be with your painting.

Now I'd like you to choose any colour paint in fluid or heavy body and mix it with a bit of white paint to make it opaque. Then take your foam brush or a wide brush and cover up at least one-third, if not two-thirds of your painting. Yes ... go on! It doesn't have to be a whole block you cover up, just sections here

'Painting is a blind man's profession. He paints not what he sees but what he feels.'
Picasso

and there. Feel your way mindfully with this part. Retain any parts of the painting you like, cover up the bits you don't. Easy, just like that.

Don't be afraid of the dark. Sometimes students will work on their canvases for days, overworking passages, making mud, getting lost in detail and not enjoying the process. I urge them as I urge you, be brave! This isn't the last layer you'll be adding, so if you are overworking something be brave, save the details for the last layers. Take some black, or a very dark colour, and cover up some areas. This is a brilliant, bold move and, counter-intuitively, will free up your painting. You'll be creating the equivalent of the dark night sky. Necessary so you can add the stars later.

Repeat

Yes, back to those first few layers, some drips, dribbles, lights, darks, just as in the early steps of your painting. Add some shapes, words, images from your scrap book / sketch book, and then cover some parts up again. How much you cover up is up to you. Try and feel your way gently with this, do what feels right. Aim to cover up and let go of any areas that you're not thrilled with and reserve any areas that you quite like.

Remember when you are covering up an area all you are doing is allowing a new bit of

'blank canvas' to emerge. OK so it may be a pink bit of blank canvas but you get the idea. It's a new space for more creativity to begin. Embrace it.

Add and subtract

Think about how to add some interesting marks to your painting. Perhaps drawing on with a brush, stamping on with a sponge, using a stencil or scratching into the paint with sharp end of a brush. Or you could try drawing on the dry surface with oil pastels for interesting textural contrast. As well as adding to your paintings, keep in mind that you can also at any point subtract paint from passages. Do this by carefully scratching into the surface of dry paint with a palette knife and lifting sections of the paint off. This gets easier to do when you have built up several layers. It's always a thrill to see what will be revealed underneath.

You can also subtract areas of paint from wet passages by wiping over them with a baby wipe, rag or piece of kitchen roll.

Incorporating a colour scheme

Well done you! You've got two paintings well underway, incorporating many colours and shapes, now let's move them on. At this point we need to get a tiny bit technical and talk

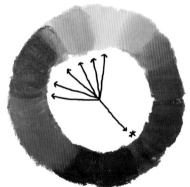

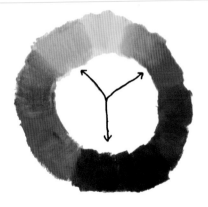

Complementary
colour scheme

Analogous
colour scheme

Triadic
colour scheme

about colour. Yes, it's time to practice what you learned in the chapter on colour earlier in the book.

This is also where the real magic happens and with just a little guidance from colour theory your paintings will start to develop harmony and really come alive.

If you're feeling a little anxious, please relax. Take the pressure off by remembering as you move through these layers that you are not finished yet. You can add many, many more layers, change your mind, cover up and redefine you painting anytime you like. After about fifteen layers the paint will become a bit slick and any more layers will have difficulty adhering. If you're at this point and you want to add more, just take a wire wool pad, or sand paper to your painting and rub sections of it down. Then onwards!

Now refine your painting by adding opaque and/or transparent layers that will make your painting into a complementary, analogous or triadic colour scheme, whilst minimising

(painting over) most of the rest of the colours, but do leave some little bursts of these other colours as they will add great interest and variety.

Look and see what the dominant colours are in your painting. For example, if you have a mainly yellow/green painting you could add violet to your painting, whilst minimising other colours except the yellow/greens will create a complementary scheme.

Or you could choose an analogous scheme by increasing the greens and yellows, and adding splashes of magenta whilst minimising other colours in the painting.

Or with a mainly yellow/green painting you could opt for a triadic scheme and choose to include more violet and orange into your scheme as supporting colours.

So off you go, adding another layer of paint and ideas from your sketch books, but this time using only your refined colour palette.

Refining

Now keep on working with what works and keep on covering up the bits that don't. Focus in on what feels good, and keep on doing that whilst staying with your colour choices. This is not to say you can't change your mind about your colour scheme – of course you can! Just do it consciously, mindfully. Love the blue against gold? Do some more. Love the leaf shape? Do some more.

As you continue to refine your painting, you'll naturally be drawn to focus in towards the details on your painting. Perhaps with a pen filled with acrylic ink, or perhaps with a fine brush. Whist your painting is taking shape, remember this is a mindful process, step back often to assess progress. As the

If you're feeling a little anxious, please relax. Take the pressure off by remembering as you move through these layers that you are not finished yet.

painting begins to resolve itself you'll find that you'll naturally be spending more time stood away from the easel, allowing time to look and listen to what your creativity and the painting are telling you.

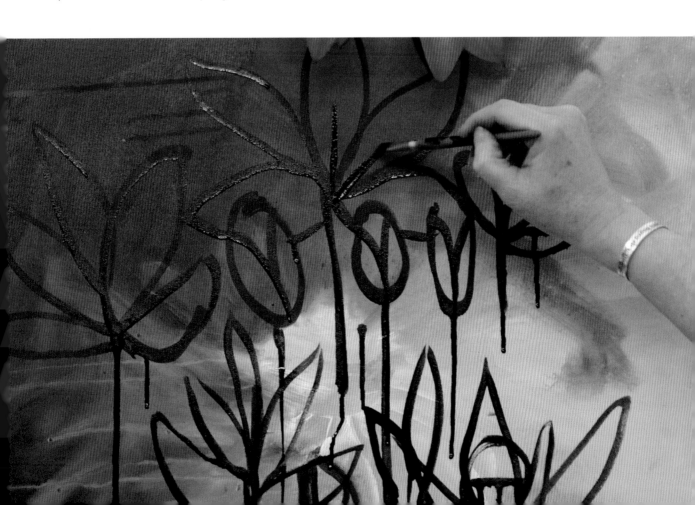

It's still early days yet, far too early for your painting to be anywhere near where it will eventually finish. With this approach to painting, you are not just painting a picture, you are developing your creativity, and that will take time. Forget the idea of painting a picture in one session. That kind of notion is for popular TV programmes, entirely constructed to fit TV schedule demands. This is a process of evolution. Your creation is evolving. You are evolving. You are learning. Assist this process rather than restrict it or hinder it by confining or defining what you want your painting to be, or expecting it to emerge, fully formed by teatime.

Patience, my friend.

Comfort zones

Comfort zones are small and get smaller as we age, so it's vital to stretch and get out of them, because, trust me, this is where the magic happens. It's where you need to set your intention upon.

Keep on pushing the edges of your comfort zone. You will recognise the edges of your comfort zones quite easily when you are painting if you are painting with your intuition. The edges of it are where feelings of discomfort start, those feelings of 'what next? Where am I?'; the 'eurghh', the 'arragh' feelings. If you have these, be assured, you are in that most excellent place where the real learning and magic happens. All you have to do is breathe, accept the

With this approach to painting, you
are not just painting a picture, you
are developing your creativity, and
that will take time.

Challenge yourself. For example, choose colours you wouldn't normally work with, or paint on a larger canvas.

feeling, be brave and explore.

Stay with the painting, don't put your brushes down and leave the room. Be with the discomfort, gently work through it. It's a teacher and a gift.

If you are painting along and it all feels very nice, and you're thinking "ha, this is easy", I'd urge you to review these lessons, and maybe gently challenge yourself. For example, choose colours you wouldn't normally work with, or paint on a larger canvas. Embrace the dark side, go deeper with your colours. Turn your painting around, upside down. Paint some words on your canvas, cover up some sections.

Start with Yes. Be brave. Experiment.

Finishing

Finishing is something I can't tell you how to do ... because only you will know when your painting is finished. This can take hours, days, weeks, even years. A recent painting of mine took five years to finish ... but I didn't give up on it, just kept going, layer upon layer upon layer. And guess what, it resolved itself in the end. I just had to commit to it for long enough. I was glad I did as it sold the day it was finished. I know this sounds far-fetched but just a few days ago the same thing happened again. This time it was a three-year-old painting. But creativity is like that. Sometimes things take time, patience, persistence and belief.

Don't ever give up.
Expect the best.
Keep working.

Here's how I know when my painting is finished. When I can stand back, look at the painting and feel ... content. When I cannot think of another thing I would like do to it.

But if you are not quite at that stage yet, here's a checklist that may be helpful in finishing off your painting.

Checklist for a finished painting

Are there any parts that look unfinished, if so work more on them. Do your eyes flow over or do they get stuck in a section, if so change that section.

Does your painting have these elements?

• a cohesive colour scheme

• quiet areas and areas of interest

• areas of value contrast, bright brights and dark darks.

If all of the above are present and correct try one or a few of these additions

• add some words

• repeat a shape or pattern

• apply a glaze of colour

• include a burst of a new colour

• introduce a new dark or light area

• ...and don't forget there's always glitter.

A painting's progress

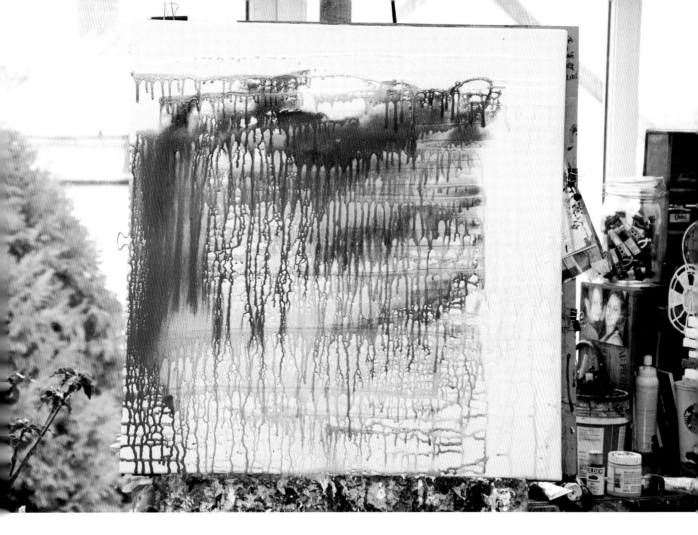

Here's one I made earlier

Here you'll see a painting progress from start to finish, illustrating the methods outlined in previous chapters. For this demonstration I'm using a 60 x 60cm canvas straight out of the wrapping. I'm using whatever colours and shapes hold my attention. For the first few layers I have no preconceived ideas of what the painting will be.

Step 1. Here I've first misted the canvas with plain cold water from a garden plant sprayer. I'm using only cool colours on this initial layer. I've dripped acrylic inks in cyan, light blue, sap green and fluorescent green on the damp canvas. Then I've turned the canvas 90 degrees on the easel, and let the inks run to form some lovely abstract patterns.

When I'm happy with the drips, I dry the canvas thoroughly. It's very important to ensure the paint is completely dry before moving on the the next layer which will be a warm colour layer. This is because if you mix warm colours (reds, yellows, oranges) and cool colours (blues, greens) you'll get dull colour mixes. The key to keeping colours bright and beautiful is to keep cool layers and warm layers separate. This method works very well with acrylic paints as when each layer is dry it forms an impermeable, waterproof, layer. Painting on top will not dull or disturb the sealed under-layers, as would happen with watercolours.

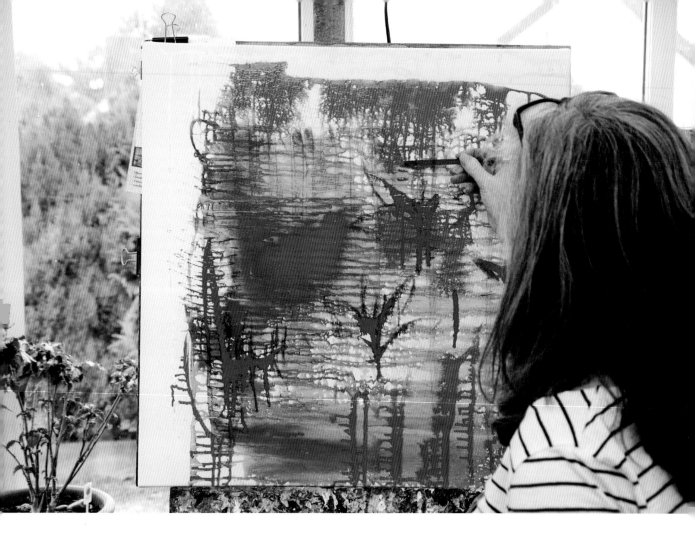

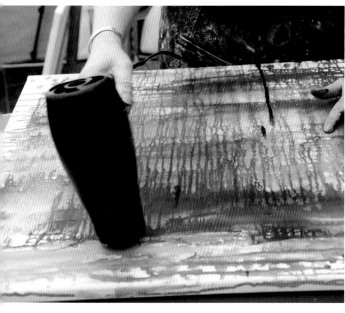

Step 2. Is a repetition of step 1, but this time using only warm colours in reds and pinks. Again the canvas is sprayed with water, acrylic ink dropped on and the canvas rotated. This time I am etching into the wet paint with the non bristle end of the brush, drawing lines, suggesting words, moving the paint around until it begins to dry naturally or I am happy with the abstract patterns that are developing. More warm colours are added in oranges and yellow inks.

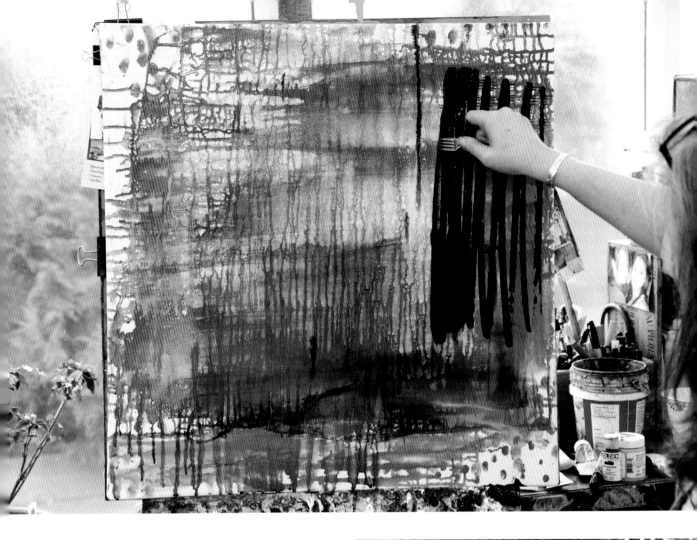

Step 3. Time to add some areas of high contrast, which will give the painting interest, by painting on a layer of black. Don't be afraid of adding black or really dark colours to your canvas as they are necessary not only to make areas of interesting contrast, but also to provide a dark background for subsequent light areas. I like to use heavy body acrylics for these layers, as I can etch into them. Here I'm using a little plastic fork to make some random, but pleasing marks. When the black is dry, I repeat the process with white paint. The white spots are done by dabbing paint on with my little finger. You could also use fluid or acrylic ink for this layer.

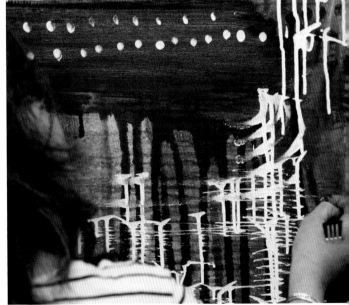

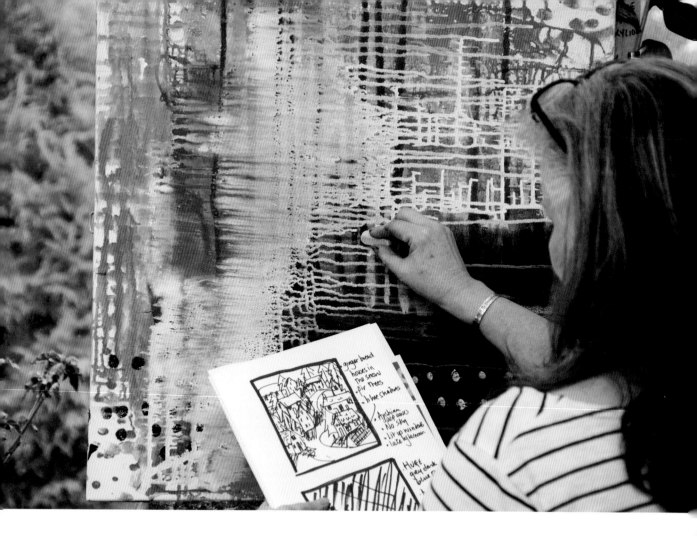

Step 4. Now I have a few pleasing abstract random layers, I can step back and look to see if any areas draw my attention. In this case I'm drawn to an area of blue that has white paint flowing though it. Something in the line and the icy blue colour reminded me of a sketch that I made the the year before of a village in the Austrian-German border.

So I take up my chalk (ensuring the canvas is dry) and begin to apply elements of the sketch, the tree shapes and house shapes in this example, to the canvas, wiping the chalk off several times until I'm happy with the outlines. Then I commit them to canvas with black acrylic ink applied with a wide brush.

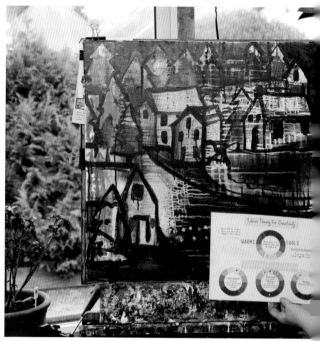

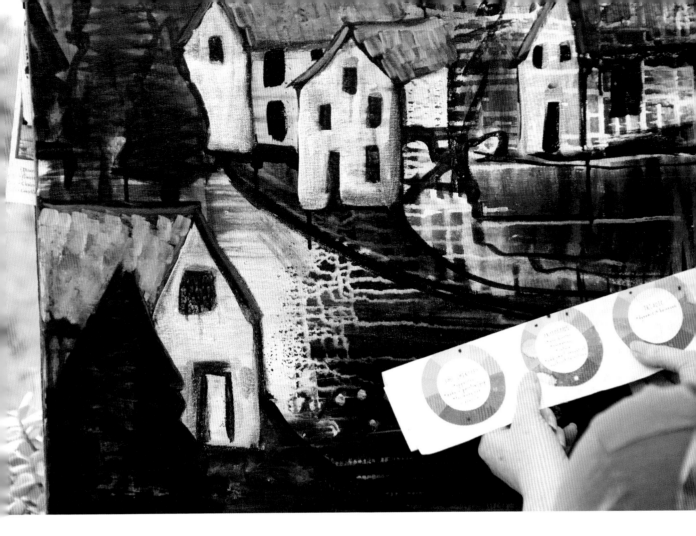

Step 5. I continue adding to the painting, not slavishly following a photo, rather painting a shape then stepping back to assess what works well, and then repeating this process until I've ended up with a village scene. The flow and shape of the painting were based on the random drips and shapes of the initial layers. It's only now, several layers in, that I'm beginning to apply some structure to the painting – but even that can change as I move on.

This is the beauty of acrylics, if I don't like what's there I can cover it up with a layer of opaque paint. If I do like it I can enhance it with transparent glazes. It's good to remember that wet paint can also be wiped off before it dries, so when applying a new layer I always keep a cloth to hand.

I'm happy, for the moment, with the outlines on this painting, so now I start to think about applying a colour scheme to it. The existing dominant colours are blue, orange and pink. I refer to the chapter on colour theory and decide to start to refine my painting into an *analogous* colour scheme of blues and purples, with a pop of complementary orange.

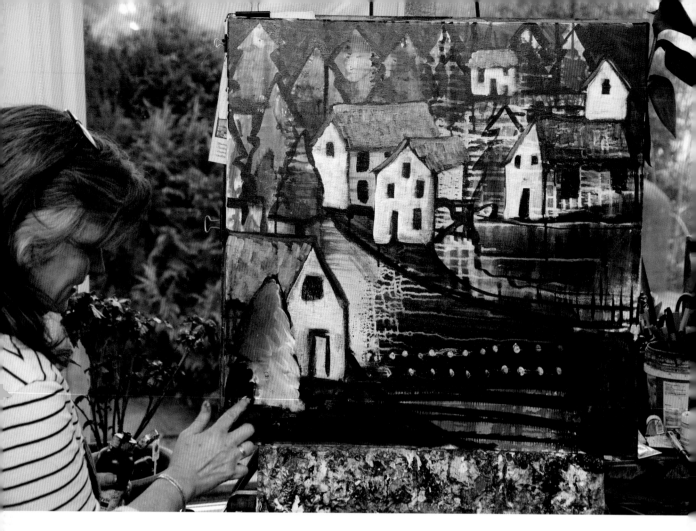

Step 6. I'm further refining and developing my painting by blocking out areas of colour that don't fit with my scheme whilst also reducing the number of 'busy' passages, thereby bringing the focus to the areas I want attention on. I block out using a blue paint, which fits with my chosen colour scheme, mixed with a little white to make it opaque. I mix the paint directly on the canvas – this adds areas of interest as solid blocks of colour can be uninteresting. I continue working in layers. Sometimes in glazes, using very thin layers of ink, high flow or fluid acrylic. Sometimes in layers of opaque, heavy body paints. All the while keeping cool colours separate from warm colours by ensuring each layer is completely dry before applying the next.

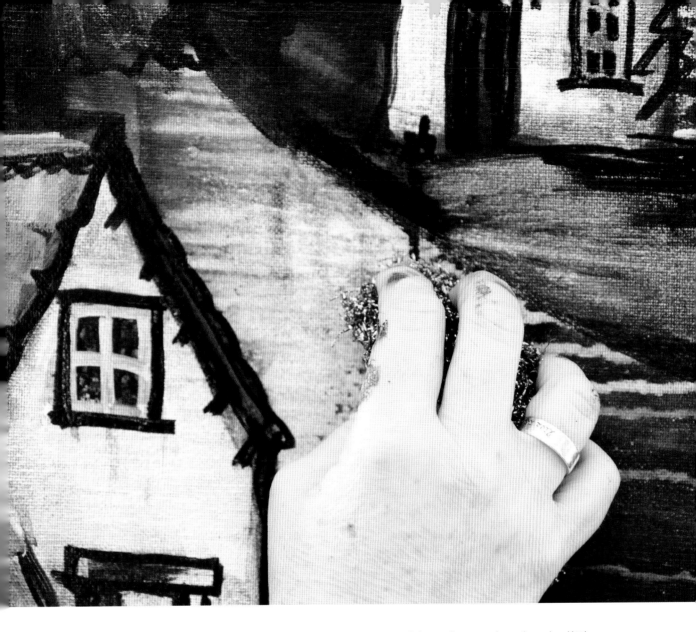

Step 7. I'm constantly stepping back to the other side of the studio to see what's working and what isn't in the painting. This is impossible to see when working close up.

As the painting nears completion I spend more time away from the painting than I do putting marks on the canvas. When I'm standing back I'm asking myself which are areas that I like? I will keep those and any areas that my eye snags on I will paint over or remove. In the example above I am gently removing an overly bright transparent passage with a wire wool pad and a little water.

This stage of the painting can take some time, as I stand back and assess and move in to remove or add a passage or small detail. It's important that I don't rush this stage, so I take my time and enjoy the choices and possibilities the painting is offering me.

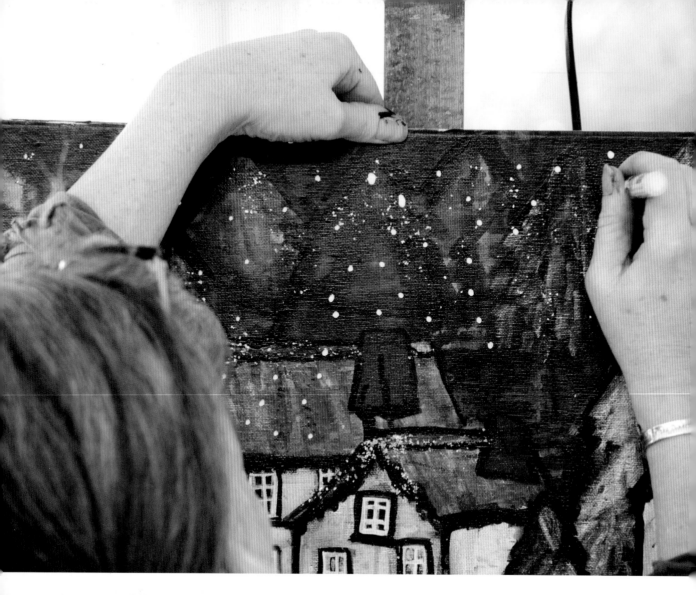

Step 8. Now I'm adding detail in the final layers. Using a special type of pen that can be filled with acrylic ink; and left, applying gold mica flake that goes on opaque because it's in an acrylic binder but that will dry clear and glossy. I'm still stepping back often and assessing my next move.

The time between me stepping back and making another move is increasing. This tells me the painting is being resolved. I know it's finished when I can't think of anything I'd like to change or anything I'd like to add, apart from my signature.

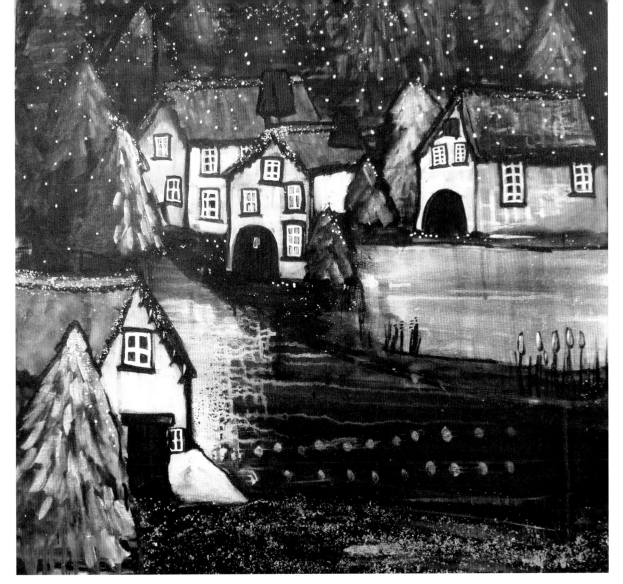

Finished Painting. 'Wolfscastle, Germany'

Onwards

This book is just the start of your creative journey. If you've been inspired, commit to carrying your creativity forward. Here's how:

• Start keeping scrap books / sketch books.

• Set goals, review progress and plan your time to fit your painting.

• Commit to noticing your thoughts and choose which ones you want to engage with. Be compassionate with yourself.

• Buy some new paint, something you don't have already.

• Push yourself, challenge yourself, move in any direction that will take you out of your comfort zone and into the vast beyond where the magic happens.

• Learn, through play and experiment, colouring mixing and a dabble of colour theory. It will pay huge dividends.

And have some fun, why not indeed.

Any questions?

I am grateful to the artists who have taken part in my 'Creative Me' workshops; for their brave and inquisitive natures and for pin-pointing for me what exactly it is that can get in the way of being creative. Here are some of their questions and my answers to them. I hope they may help you too on your creative journey.

When it comes to painting, there are a few basic techniques that, once learned, will give a solid base to grow from. This knowledge is literally the tip of the iceberg; it's what you see artists doing, putting paint on canvas. The questions the good folk who join me at the workshops mostly ask are not about the techniques, rather, they are about what lies beneath, about that which makes us creatively strong.

I never have time to paint

If this is our block to being creative, the answer is, of course, to prioritise. What we choose to prioritise is what gets done. It really is as simple as that. What we fill our minutes with is what our days become, and what your days become is what your life is. If we are really passionate about creating, if being creative is what really makes us feel alive, then we must prioritise this. Make

every effort to carve out time for creative work and to discipline ourself to use that time creatively.

Think about this, even if we spend just 30 minutes a day making art, we'll still be spending 23 hours and 30 minutes doing the things we are prioritising above your creative life, each and every day.

And if you're questioning how important being creative really is to you, spend a moment thinking about why you are reading this book. And then give a thought to how you feel when you don't paint for a week, a fortnight, or, can you even imagine this, a month. One of my favourite authors, Liz Gilbert, compares her creativity, her writing, to a bored sheep dog. Un-worked it will start causing all sorts of trouble, destroying things: the sofa, the postman, relationships, her peace of mind. I like this analogy and I think it may well be true. Creativity demands an outlet, for sanity's sake.

In our house there came a time when the children were teenagers, my husband and I both worked full time and I was obsessed with painting. With the demands of work, children and home I was finding it very hard to find time to paint. I still didn't dare dream that painting would become my life; literally

didn't dare. I'd had some early success in that I was thrilled with some of the paintings I'd made – I'd even sold one or two. This encouraged me, although to be honest, I didn't need much encouragement. I painted, drew, sketched and coloured-in everywhere. But still there came a point where I just wasn't getting enough time to paint. I had a good career at work, one I'd worked hard for, and I couldn't afford to think of reducing my hours or leaving.

So here's what I did to carve out some painting time, because there's no way that I was going to let those paints I could barely afford harden and shrivel in their tubes before I had chance to use them.

I gave up TV (apart from the rare film). But you know, I still didn't have enough time. So I gave up housework, well almost. I developed a great tolerance for dust and unswept floors. Well, you know, there were four of us making the mess, so it made sense to me that four of us should be cleaning it up. This gave me some time to paint most nights when I got in from work, and I often got in late, after 8pm.

I didn't do this because I had a dream of fame and fortune, or because I thought I could be a good painter. I did this because when that streak of blue paint resonated against the coral background my heart sang, my little creative world was rocked, it made sense and I was happy. I did it because I couldn't not do it.

I not only followed my passion, I stalked it. Oh, and I used my diary. Yes, properly, as if I was at work. I scheduled painting appointments with myself and I kept them. When inspiration showed up I wanted it to find me working...

Fear of failure

That old chestnut! Here's the truth, it's not failure that we fear – I hope by now I may have convinced you that so-called 'failures' (a.k.a experiments) along the way are in fact essential to growth. No, it's not fear of failure that stops us, it is fear of fear itself.

And of course, once acknowledged, looked at, explored, understood and put back in its box, fear can no longer hold us back in our creative pursuits. What holds us back is our made-up ideas of how scary things are, we literally create our own fear of fear. Crazy I know, being afraid of a completely imaginary construct. Behind all the fears that students list about being creative is this fear of how scary their fear is. Honestly, it's not the fear of failure, or the fear of results, judgements, critiques, success or anything else we associate with creativity; but just fear of fear.

To address this, be brave, have a good look around in your mind and see what fears about creativity you may have. And then, pop them in a box marked "only to be opened in real life or death situations, for example when wild animals are storming the house" or some such other label that clearly puts fear in its right place, and leave it there. Packed away. Ready to use if in actual fact you do need it. Fear has no place in your creativity. Play, fun, laughter,

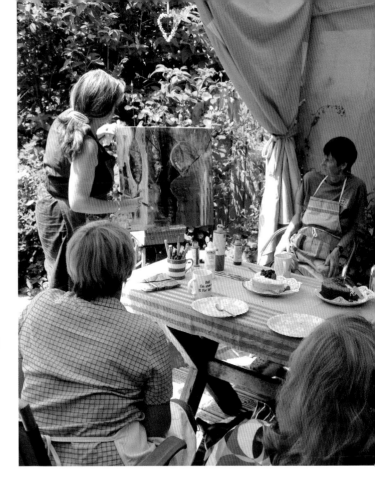

experimentation, falling, getting up, running, all have a place there. But fear, a primal survival instinct, is not useful to our creativity and will kill it.

I've many personal examples of fear getting in the way of my creative life, so many in fact that I have painted a picture that hangs on my dining room wall about it, to remind myself of the amazing opportunities and experiences that are waiting when I'm brave and face my fears.

I find that I am editing and censoring myself

This seems to me to be about expectations of what others may think. But listen, how can we ever truly know what others are

thinking? We can try and guess, but these guesses will always be filtered through our own thoughts and therefore distorted. So, given that we cannot know what others are thinking, we may as well not concern ourselves with it, especially when it comes to artwork. We are very fortunate to occupy a place in time and geography that allows us freedom of artistic expression. It would be churlish not to fully use it.

Starting isn't too much trouble but having some idea of where I'm heading is. Where to find inspiration?

An important point, and the answer lies in those scrap books / sketch books and having them to hand to refer to when we get stuck. We can remind ourselves what inspired us when we were filling our sketch books.

The other thing I'd like to say here, about the method of painting in this book, is that we really do not need to know where the painting is heading. In fact, right up until the last layers (remember that can take a few years) it's important that we don't know. Paintings done by the method in this book will evolve themselves and teach us lessons in creativity, given time and commitment.

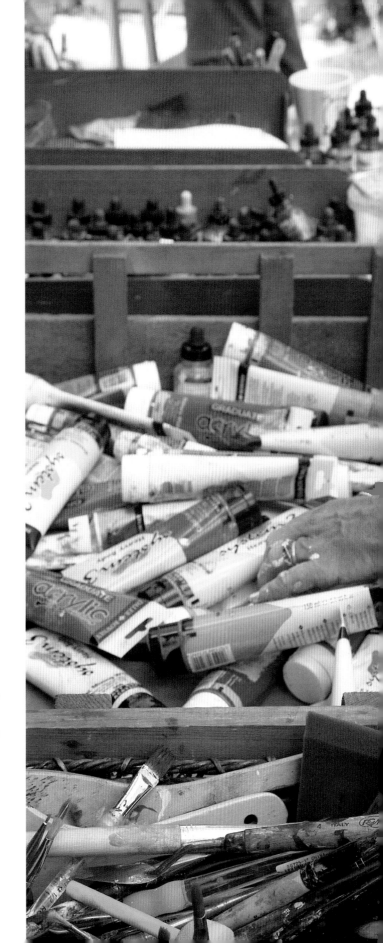

Sometimes it's finding the courage

Until I got questions like this I never quite realised how scary the whole creative process can be for many people.

In my experience this scariness is just good old self doubt, which is entirely understandable. Many people want to be creative but they have a lot of doubt about their abilities. Of course they do. There are only a very few people who are able to create amazing art work without years of practice. There is a saying that it takes 10 years or 10,000 hours to become expert in a craft. So our self-doubt is genuine, we know we will need a lot of practice before we produce art that will hang in galleries, so we really should not be afraid of it. Be brave and get started on those 10,000 hours!

We can learn to live with self doubt simply by developing a self-belief and a self efficacy in ourselves. And I say simply because I mean it. Painting using the methods in this book will help increase your belief in your ability to paint. And the more we develop belief in our abilities, the more enthused we'll be to practice, and the more we practice the more likely we are to suceed. I do hope you will try it and find out.

Relax and have a good laugh at yourself. Laughter is a really great way to let the tensions go that are present in our creative learning. It gives us perspective, exercises our lungs, oxygenates our brains and makes the world feel lighter.

Ask yourself, what's the worst that could happen? As I say, it's only paint and it's only canvas. The rest is baggage we've added on, our ideas of what an artist is, ideas of how a painting should be. Perhaps, when we think about it, these may not be useful to us anymore.

The fear, or knowledge, that what I will create will be rubbish

Learning to trust my own intuitive creative process has been key to my artistic development and I continue to learn with each new canvas. I've learned not to judge what gets onto the canvas through my hand too soon. Quite often, the apparently random pursuing of a creative urge, that intense feeling you get when the line is flowing and the colour is amazing, will lead to a new insight, a new depth to my painting.

What a massive block we put in place when we claim to 'know' that we'll create 'rubbish', and that we let that thought stop us. Well, maybe we'll create things whose natural home is the recycling box, (remember 10,000 hours) but that really does not matter. In fact, it's an essential part of our creative experimentation. The point is that we have created something and that we have developed our creativity by doing so.

It's a fact that we all create art that we are not happy with, and, you know what, all artists of whatever expertise or experience do this too. It's part of the job description so the sooner you can accept it and use it to your benefit the better. Deep at the back of this particular fear lies comparison with others. This is so sad, because

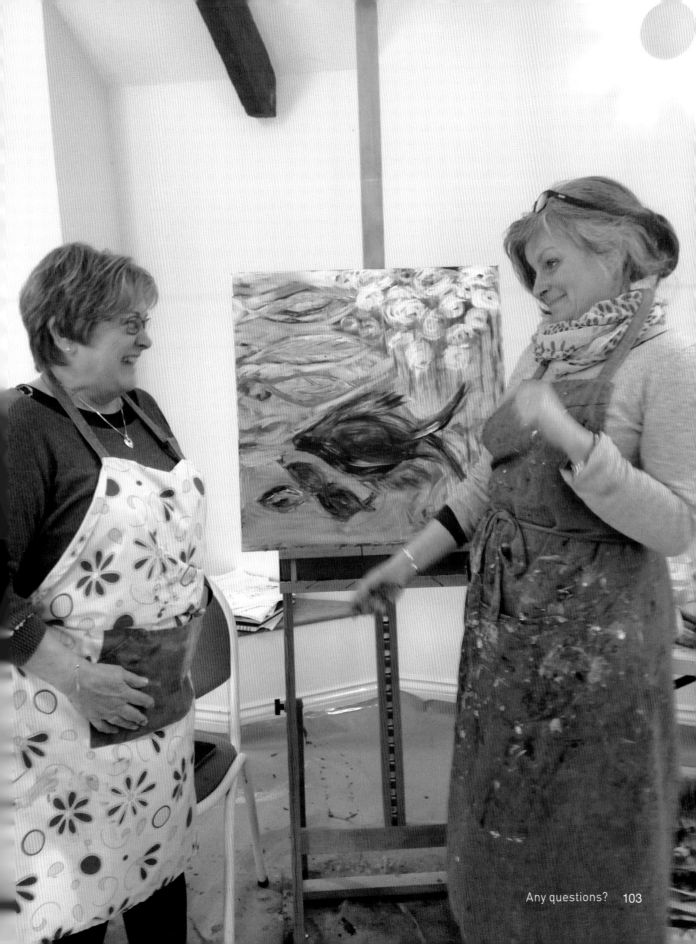

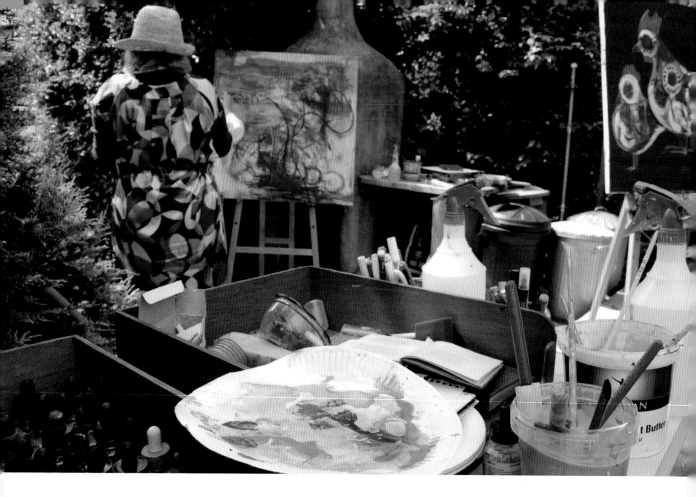

comparing ourselves with others is of no use whatsoever, and yet we have allowed our ego to make this a big, huge boulder that blocks our creative path. Our egos are such fragile things, they puff themselves up like car airbags, a protection from the reality that, in fact, we are all small and vulnerable and need each other's help to get along. It's our ego that wants us to compare ourselves and our paintings with others, to assure itself that it's the best. But of course we never will be 'the best', there will always be a 'better' painting somewhere by someone.

And of course art is so beautifully subjective, one person's Mona Lisa is another's Duchamp's Fountain, so you can see that comparing our art to anyone else's is a waste of our precious time and creativity.

Does this mean that if we can't be the best in the world that we give up? What do you think?

Now we've seen what's behind this particular fear, we can simply let it go. Take a big breath and literally Let It Go. This one step will free up your creativity no end. Just remember to be nice to yourself when you find yourself back with your old habit of comparison. Be grateful that you've been mindful enough to recognise it.

Another small thing, whilst we are here. Note down, or better still, 'draw down' what you think of this in your sketch book, as a reminder. I wouldn't like you to forget and have that big old boulder of comparison block your way again now would I?

The end product doesn't always reflect my initial idea and I end up disappointed

I think I have the answer to this. It's about expectation. And you know what I'm going to say about that don't you? Let it go. Let go of expectations. For example, if I had an idea to paint a 'perfect' horse, much as I love horses and know the equine form, I'd fail. But if I let go of the expectation of painting a 'perfect' horse and focused rather on the colour, sound, texture, movement, smell of a horse and let myself play with those sensations in paint, well it still wouldn't look like a perfect horse but I would have had some fun and immersed myself for a happy hour or two in horsiness, and you never know what may result. After all what's the worst that could happen? I'd end up with a canvas that I could paint white and start again. And what's the best that could happen...?

We can choose to think of each piece that we paint as stepping stones on our creative journey. We will never get to the next stage of development as an artist unless we are willing to take those steps.

Art is so beautifully subjective, one person's Mona Lisa is another's Duchamp's Fountain.

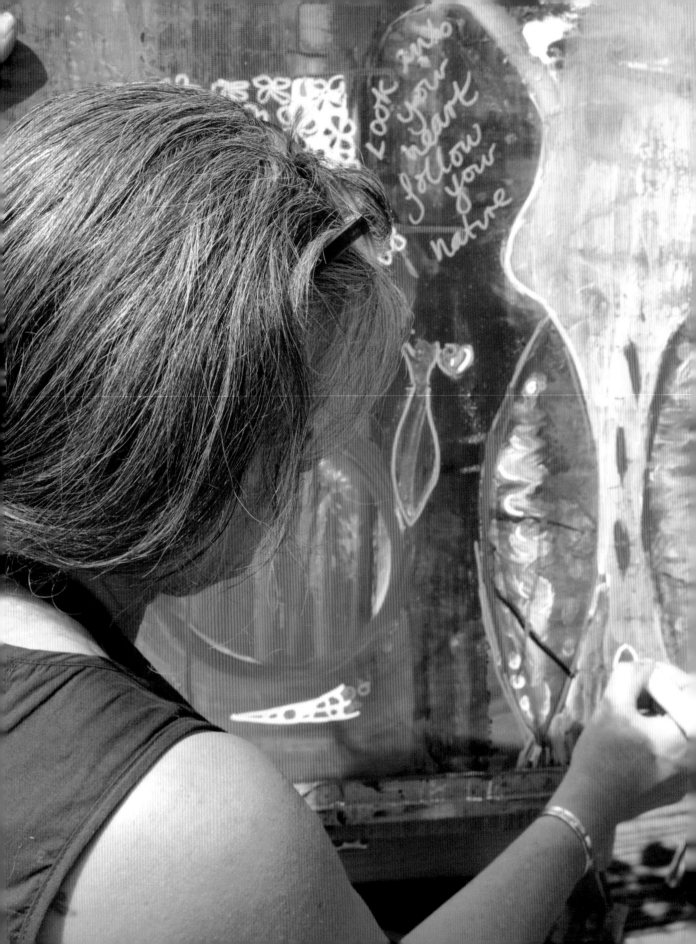

Having got rid of the expectation, the vision of what a painting should be, we free ourselves to be creative. Letting go of expectations, self imposed and imposed by others, is the first step to true creative expression. It's like learning to swim and experiencing the sensation of being afloat in a warm ocean, confident in the water, sweet and freeing.

So here we are, my final words to you before you rush off to make your magic. Start with Yes, keep painting, learn to live with ambiguity, keep on experimenting, evolve, grow in self-efficacy and try to be gentle with yourself.

Let go of comparing.
Let go of judgments.
Let go of expectations.
Let go of fear.

And laugh out loud, especially if it's at your inability to let go of the above.

Trust me, I'm an artist.

Gratitude

'Give what you can; whether it is knowledge, protection or inspiration.'
HH Gyalwang Drukpa

Since the conception of this book, some four years ago on a beach in the south of France, I've been intent on including a chapter on gratitude. Having 'an attitude of graditude' has been the one constant that has kept me going on my creative path, through hard times and good. This attitude is what has helped me learn my creative lessons and enabled me to share with others the joy I continue to find in painting.

I am grateful that I am able to pass on some of this knowledge to you, the essence of which, for me, is this: the active paying or giving attention to your art, to those around you, to nature, and to the smallest reflection of light on a drop of water will lead to appreciation, which in turn will lead to gratitude.

If we take time to quieten our minds and pay attention, to look for the good things in our paintings and in our life, then appreciation will blossom. We will see more opportunities and helpful lessons that come with life's, and our painting's, challenges. Being appreciative in this way encourages confidence, and rather than being fearful of the lessons and what may happen, we can be relaxed. We are happier and more productive when relaxed and more able to be appreciative, unlike when we are stressed or angry because life, or a painting, hasn't gone as we expected. That's it really. Get hold of a few good paints, pay attention, appreciate and be grateful without expectation, and creativity will come.

When thinking about the people I am grateful to for their help and inspiration with this book, I started with the people who have helped and inspired me in the last few months. Then the last few years. And I realised that in-fact the gratitude and appreciation I was feeling stretched way back, as far, in fact, as some of my earliest memories. It was a lovely thought. The list of these people is almost endless, and certainly too long to ask you to read. Perhaps as you read through this edited list, it may come to mind of how connected we all are, and how the smallest act of kindness, generosity or inspiration can go a long, long, way.

Mostly these are people that you may not know, but that I am truly blessed to have had in my life. It's a fact that no one creates anything of real value by themselves, and I am therefore grateful to the lovely people who have all, in their own ways, made 'Creative Me' possible.

Mrs Karolas, my first form school teacher who said I could do well if I tried, and Mrs Brittain, who tried to teach me punctuation and grammar. Whilst writing this book, I have often thought fondly of her, and the large, mechanical pencil sharper she kept on her desk that I loved to use, when allowed, and of the stories she read us under a Weeping Willow in the summer months at school.

My Uncle George, for the gift of the disappointing paints that launched me into a life long quest for the juiciest, the brightest, the most captivating of colours.

My art teacher at senior school, for asking me to leave the class, thus ensuring that I studied science and found inspiration there, and a subsequent non-art career that gave me skills in the field of psychology that help me inspire others today. I'm also grateful to him for ensuring that I would eventually be unable to suppress the desire to be an artist any longer, and so had to teach myself technique, resilience and self-confidence.

To Caroline Morgan, who gave me a career which developed my understanding and practice of adult cognitive-behavioural psychology and business management. Both essential skill sets, as it turns out, that have enabled me to fully develop my career as an artist and teacher.

To the lovely lady who bought the first ever painting that I sold, from a local art society show, and of course to the art society members for keeping the society going and putting on the show.

To Richard Brain at Fountain Fine Art Gallery in Llandeilo, who gave me my first solo show and displayed a large painting in such a way that a couple were queuing to buy it before the gallery doors opened on the first day of the show.

To Patti Brady, just for being herself, but also for taking a chance with me and admitting me onto the Golden Artists Educator Programme in the USA and thus necessitating that I overcome my fear of flying, and therefore, literally opening up the world for me.

To David, Chloe and Charis, for being beautiful people and for their encouragement, constant loving kindness, and endless hours of proof-reading.

To Caitlin Tyler, for her wonderfully creative photography, and for working closely with me over the past few years to build a beautiful record of my paintings.

To Maggie Schmid and Katherine Rich, my right hand women, intelligent, funny, individual, strong and beautiful. I'm so lucky to have you on the team.

To my publishers Peter Gill and Matthew Howard for believing in this book even before I really did, and my designer Joana Rodrigues for making it look fabulous.

...and to His Holiness The Gyalwang Drukpa, my thanks.

what we think, we become

Books on my shelf:

Everyday Enlightenment, HH Gyalwang Drukpa

Consolations, David Whyte

Brave Intuitive Painting, Flora Bowley

Re-thinking Acrylic, Patti Brady

Big Magic, Elizabeth Gilbert

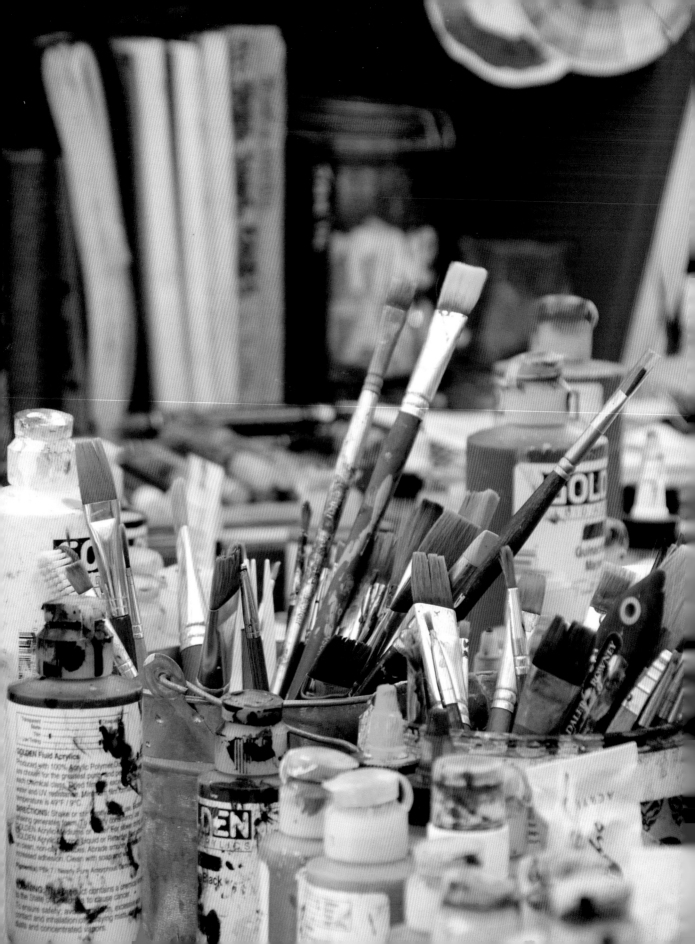